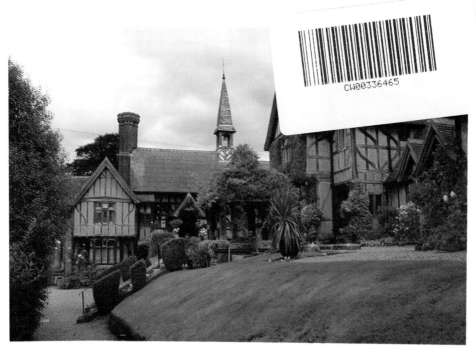

The St Mary's Homes in Godstone (Surrey) were built by Sir George Gilbert Scott for Mrs Augusta Nona Hunt in memory of her daughter Mabel. The craftsmanship is exceptionally high.

Almshouses

Anna Hallett

A Shire book

TO PIPPA AND PAUL

Published in 2004 by Shire Publications Ltd,
Cromwell House, Church Street, Princes Risborough,
Buckinghamshire HP27 9AA, UK.
(Website: www.shirebooks.co.uk)

British Library Cataloguing in Publication Data:
Hallett, Anna. Almshouses. – (Shire album; 425)
1. Almshouses – Great Britain – History
2. Almhouses – Great Britain – Pictorial works
3. Aged – Dwellings – Great Britain – History
4. Aged – Dwellings – Great Britain – Pictorial works
5. Architecture, Domestic – Great Britain – History
6. Aged – Great Britain – Social conditions
7. Charitable bequests – Great Britain – History
I. Title 725.5'5'0941.
ISBN 0 7478 0583 0.

Cover: *Beamsley Hospital (now a holiday cottage owned by the Landmark Trust) near Skipton was founded in 1593 for a community of twelve Sisters and a Mother. Six of the Sisters and the Mother lived in wedge-shaped rooms surrounding the chapel (still intact, complete with bell), while the remaining six found shelter in a row of cottages fronting this unique structure. See plan on page 34.*

ACKNOWLEDGEMENTS
I thank the many people who over a period of three years helped me to build up a picture of almshouse life, past and present. These include staff at the Almshouse Association, the clerks and trustees, masters, matrons, wardens and residents of a large number of these charitable institutions, and archivists, librarians and museum staff in many parts of Great Britain. I am also grateful to all those – friends, relatives and students – who alerted me to increasing numbers of almshouse buildings and, last but not least, to those whose IT skills allowed me to achieve the final product.
Illustrations are reproduced by kind permission of: the Trustees of Abbot's Hospital, Guildford, page 6 (top); the Trustees of the Almshouse of SS John, Sherborne, page 4 (top); Birmingham Library services (from the Sir Benjamin Stone Collection), page 16 (bottom); the Trustees of Browne's Hospital, Stamford, page 6 (top and bottom); the Patrons of Cowane's Hospital, Stirling, page 42; the Geffrye Museum/Morley von Sternberg, pages 44 (bottom), 45 (top and centre); the Trustees of the Lockerby Trust, Edinburgh, page 45 (bottom); Mr Stewart Ramsdale, page 38 (top); the Trustees of St John's Hospital, Bath, page 43 (top); the Trustees of St Mary's Hospital, Chichester, pages 6 (top) and 7 (top). Other illustrations are acknowledged as follows: photographed by kind permission of the Carpenters' Company, London, page 13 (top); with thanks to Pippa Hallett, page 40 (bottom); Cadbury Lamb, page 9 (top) and cover; by courtesy of the Mercers' Company, page 4 (bottom), 39 (bottom); Remaining photographs are by the author.

Printed in Malta by Gutenberg Press Limited, Gudja Road,
Tarxien PLA 19, Malta.

Contents

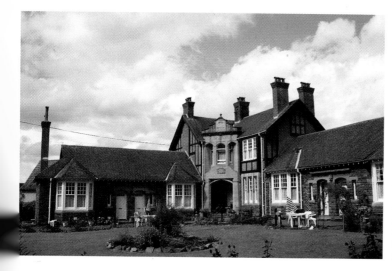

St John's Almshouses in Bristol, with buildings dating from 1907, have been renovated and blocks of new flats added.

Early developments

When Dr Samuel Johnson expressed the opinion that 'A decent provision for the poor is a true test of civilisation' he voiced a belief that many through the ages have acted on – though some almshouse donors were also motivated by thoughts of personal salvation. In the foundation deed for his 'Almeshouse' in Morcott (Rutland) dated 10th June 1612, George Gilson mentions 'the laste and terrible daye of Judgmente when the secretts of all hartes shalbe disclosed and everie man shall gyve an accompte of his wayes workes and deedes'.

Among the many charitable schemes that exist, almshouses, built

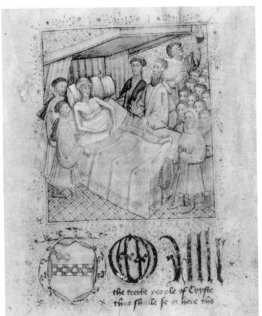

Richard Whittington on his deathbed, surrounded by his executors and the inmates of his almshouse. From a copy of the ordnances for the almshouse made for the Mercers' Company in 1442.

Right: *Jesus Hospital in Rothwell (Northamptonshire) was built in 1593 under the will of Owen Ragdale. As many as twenty-six men had to share, two to a room. Their uniforms comprised a navy Melton coat, grey trousers and a high silk hat.*

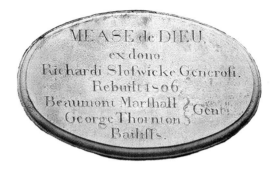

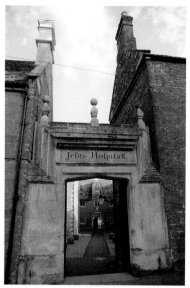

Above: *Sloswicke's Hospital or Mease de Dieu in East Retford was founded in 1657, rebuilt in 1806 and altered in 1819.*

to provide shelter for elderly people in need, are usually highly visible. They have been called 'hospitals' (pointing to the hospitality offered there), 'colleges' (highlighting their communal aspect), 'asylums' (places of refuge), 'bede houses' (using an Old English word to indicate that prayers were to be said for the benefactor's soul), 'Maison Dieu', 'Domus Dei' or 'God's House' and, more recently, 'homes' and 'cottages'. Examples are Sandes Hospital, Kendal, Sackville College, East Grinstead, the Metropolitan Beer and Wine Trades Asylum, London, Cromwell's Bede Houses, Tattershall (Lincolnshire), the Maison Dieu in Melton Mowbray, the Sir William Fraser Homes in Edinburgh and Johnstone Cottages, Dumfries. Alms people have been known as 'brethren', 'brothers', 'sisters', 'bedesmen', 'pensioners', 'dames' and 'hamleteers'.

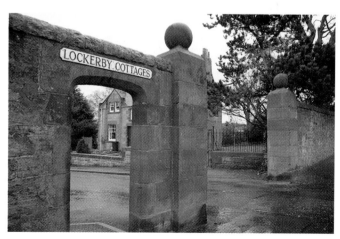

The Lockerby Cottages in Edinburgh were provided in 1894 by Thomas Lockerby, who, being childless, saw them as a way to keep his name alive. They were for 'twelve or more persons male or female who have been reduced in their circumstances by no improvidence extravagance or rash Speculation'.

5

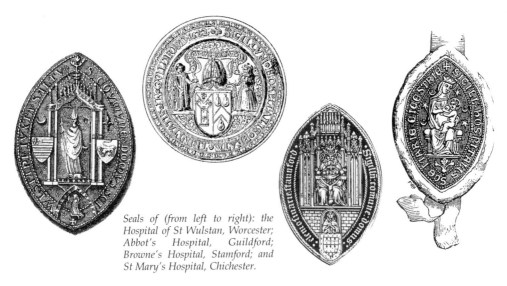

Seals of (from left to right): the Hospital of St Wulstan, Worcester; Abbot's Hospital, Guildford; Browne's Hospital, Stamford; and St Mary's Hospital, Chichester.

Below: A plan of Browne's Hospital, Stamford, as it was in the fifteenth century. The former infirmary hall on the ground floor incorporates a chapel. The space allocated to each bed shown lining the walls is even now outlined on the floor. The chapel, divided from the hall by a fifteenth-century wooden screen, contains medieval windows and furniture. This room, together with the audit room upstairs, is sometimes open to the public.

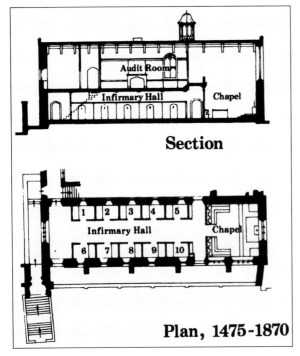

The origins of almshouses lie in medieval monasteries, where Christian duty dictated the care of people in need. Some early foundations started as refuges for lepers or pilgrims, eventually concentrating on the care of the elderly. The buildings resembled barns with beds lining the walls and a chapel at the east end, so both physical and spiritual needs were looked after under one roof. Though no longer used in this way, examples exist in the thirteenth-century* St Katherine's Hospital, Ledbury (Herefordshire), and the fifteenth-century Browne's Hospital, Stamford. In Chichester the thirteenth-century St Mary's Hospital is unique in its construction of individual dwellings within what, on entry, appears to be a large church. In the fifteenth-century Almshouse of SS John, Sherborne (Dorset), the chapel, which is an extension of the hall, is open to the

* NOTE: Except where stated otherwise, dates refer to the foundation of the charities, not the buildings in which they are housed, which may be of a different period.

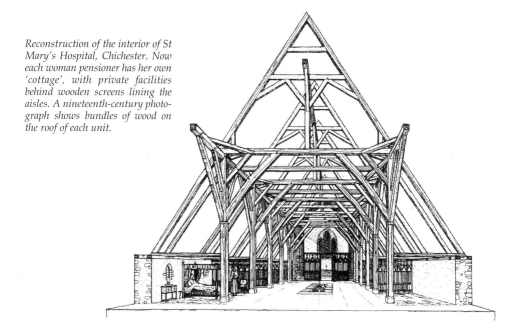

Reconstruction of the interior of St Mary's Hospital, Chichester. Now each woman pensioner has her own 'cottage', with private facilities behind wooden screens lining the aisles. A nineteenth-century photograph shows bundles of wood on the roof of each unit.

first floor, where the men had their dormitory (each with his own 'bedde and bedde place by hymselfe'). In Glastonbury the thirteenth-century Hospital of St Mary Magdalene started life as a hall building, but where the beds once stood two rows of cottages arose (only one was left in 2003) and the main roof disappeared. The thirteenth-century St Nicholas Hospital in Salisbury – said to be the inspiration behind Anthony Trollope's Hiram's Hospital in his novel *The Warden* – seems to have had twin naves and chapels, possibly representing male and female wards.

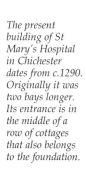

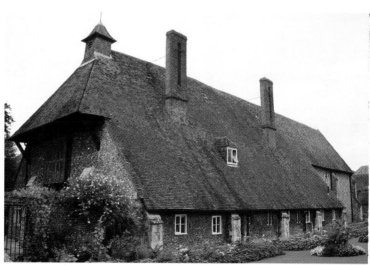

The present building of St Mary's Hospital in Chichester dates from c.1290. Originally it was two bays longer. Its entrance is in the middle of a row of cottages that also belongs to the foundation.

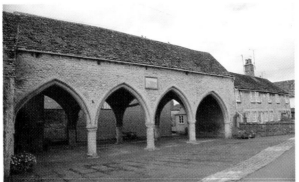

The remains of the twelfth-century infirmary hall of St John's Hospital, Cirencester. The nineteenth-century almshouses to the right of the hospital at one time extended into the ruins, as can be seen by the difference in the colour of the stonework around the repaired arch on the far right.

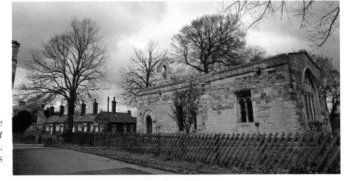

Right: *The chapel of the former leper Hospital of St Mary Magdalene in Ripon. Note the later almshouses behind.*

The courtyard of St John's Hospital, Lichfield (left), with the master's house and the chapel at the far end (site of the twelfth-century pilgrims' hostel). On the right are the renovated almshouses.

Most medieval hospitals were destroyed during the Reformation. However, more recent almshouse developments can be found alongside the ruins of St John's Hospital, Cirencester, the chapel of the former leper Hospital of St Mary Magdalene, Ripon, the Hospital of St John, Malmesbury (Wiltshire), and the chapel of the leper Hospital of St Margaret and St Sepulchre, Gloucester, all founded in the twelfth century. In Lichfield St John's Hospital, established in 1135 as a priory for the care of pilgrims, was re-founded in 1495 as an almshouse for elderly men (and a free grammar school, which has since moved on).

Donors and beneficiaries

Almshouse founders have come from a variety of backgrounds. At the highest level royalty was involved, mainly in London. The Maison Dieu in Ospringe (Kent), dedicated to St Mary, was founded (or possibly refounded) in the first half of the thirteenth century by King Henry III, who added a set of rooms, the Camera Regis, to the almshouses in which he and future kings and their retinues could stay whenever they passed, often on their way to the Continent. In the early sixteenth century King Henry VII built a large hospital for 'pouer nedie people' on the ruins of the Savoy Palace. It had three chapels, one of which survives as the Queen's Chapel, situated behind the Savoy Hotel. In the seventeenth century King Charles II promoted Chelsea Hospital and William and Mary the Royal Naval Hospital in Greenwich. In 1847 Queen Adelaide paid for the King William IV Naval Asylum in Penge, and in 1880 Queen Victoria built almshouses in Whippingham, near

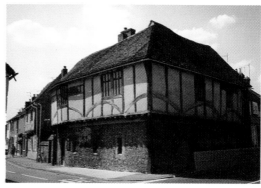

Right: *The Maison Dieu in Ospringe, Kent.*

Below: *The King William IV Naval Asylum in Penge (south-east London) was founded for twelve widows of naval officers by Queen Adelaide in memory of her husband. The building is no longer used for this purpose.*

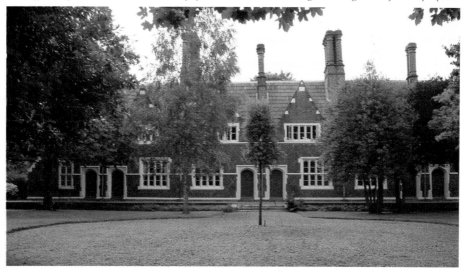

Almshouses built by Queen Victoria at Whippingham in the Isle of Wight for retired royal servants.

the Osborne Estate in the Isle of Wight, for retired royal servants.

Among members of the aristocracy Lord Burghley established the set of almshouses bearing his name in sixteenth-century Stamford on the ruins of the former Hospital of St Thomas and St John. In Sussex the second Earl of Dorset provided East Grinstead with Sackville College (completed *c*.1619, after his death), and the Duke of Somerset Petworth with the Upper or Somerset Hospital (1746). In the early seventeenth century Henry Howard, Earl of Northampton, founded almshouses in Greenwich, Clun (Shropshire) and Castle Rising (Norfolk), all dedicated to 'The Holy and Undivided Trinity'. In Greenwich twelve of the twenty (male) pensioners were to come from Greenwich and eight from the Earl's birthplace, Shotesham (Norfolk). In 1885, to prevent uprooting the pensioners of Shotesham, yet another Trinity Hospital was opened, this time in Shotesham itself.

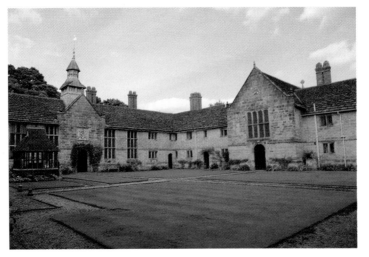

The seventeenth-century Sackville College, East Grinstead, was built with money left by the Earl of Dorset. Note the Dorset Lodgings, with its coat of arms above the entrance (once used by the founder's relatives, now the hall), the well in the quadrangle and the chapel.

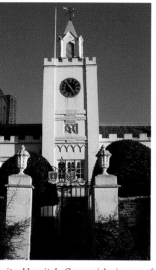

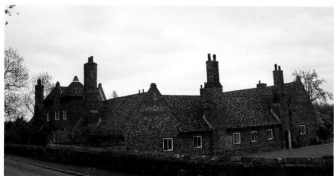

Trinity Hospital, Castle Rising (Norfolk), one of the three groups of almshouses built by the Earl of Northampton. Here the matron and sisters still wear red cloaks whenever they visit the church, though the heavy conical black hats are worn only on special occasions.

nity Hospital, Greenwich, is one of
ee sets of almshouses built by the
el of Northampton in the early
enteenth century.

The coat of arms of the Earl of Northampton on the gate of Trinity Hospital, Shotesham (Norfolk).

iity Hospital, Clun (Shropshire). There is an
resting statue in the courtyard based on two
eteenth-century pensioners, one of whom,
named 'the Bear' (because he had 'wrasted' with a
at Knighton Fair), liked to trip up schoolchildren
h his stick (see page 37).

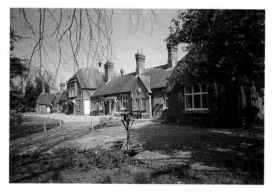

iity Hospital, Shotesham (Norfolk), built in 1885
the Mercers' Company of London (which looks
r the charity).

11

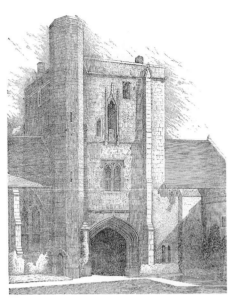

Many church dignitaries were donors. The twelfth-century Hospital of St Cross was founded in Winchester by Henry de Blois, bishop of that city. In c.1249 Bishop Walter Suffield established the Great Hospital in Norwich, while in Glasgow Bishop Andrew Muirhead built St Nicholas' Hospital in c.1470. Gabriel Goodman, Dean of Westminster, refounded Christ's Hospital in his birthplace, Ruthin (Denbighshire), in 1590, and six years later John Whitgift, Archbishop of Canterbury, founded the Hospital of the Holy Trinity in Croydon, followed in 1619 by a foundation of the same dedication in Guildford by Archbishop George Abbot. In 1661 Brian Duppa, Bishop of Winchester, provided six cottages in Pembridge (Herefordshire).

Many donors were high-ranking professionals and wealthy merchants. The eighteenth-century almshouses in Frolesworth (Leicestershire) were founded by John Smith, Lord Chief Baron of the Exchequer in Scotland, and one of the Barons of the Exchequer in England. In Brackley (Northamptonshire) Sir Thomas Crewe, Speaker of the House of Commons, donated the seventeenth-century almshouses, and in 1707 Charles Twitty, Deputy Auditor of

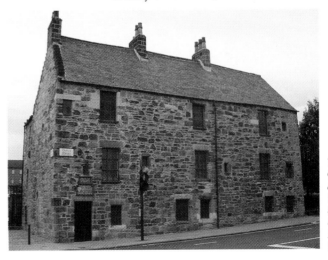

The Provand's Lordship, Glasgow, now a museum with displays of period furniture, tapestries and paintings, was built c.1471 as a manse for the chaplain of St Nicholas' Hospital. It is the oldest building in Glasgow.

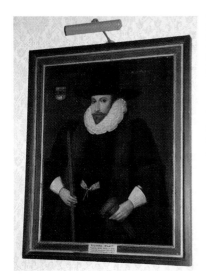

Left: Richard Wyatt, wharf-owner and timber merchant of London and three times Master of the Carpenters' Company, left money in his will for the building of almshouses in Godalming, to be taken care of by the Carpenters' Company. In 1938 the men still wore navy-blue jackets with the initials 'R.W.' embroidered in purple on the left breast.

Below: The statue of Sir Robert Geffrye above the chapel door of the former Geffrye Almshouses in Shoreditch, London, which is now the Geffrye Museum. Robert Geffrye rose to be Master of the Ironmongers' Company and Lord Mayor of London.

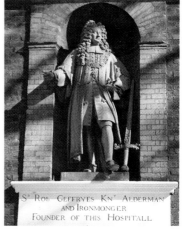

Sᵗ ROᵇ GEFFRYES KNᵗ ALDERMAN
AND IRONMONGER
FOUNDER OF THIS HOSPITALL

the Receipt of Exchequer, augmented the stock of almshouses in Abingdon. Dulwich (London) was enriched in 1619 by Edward Alleyn, actor, theatrical entrepreneur, brothel owner and 'Master of Bears', with God's Gift, for scholars and alms people. In 1668 Provost Alexander Dunbar built the hospital bearing his name in Inverness.

Donors from the merchant classes often reached prominence in the London livery companies (which could be left in charge of the charities). These included the fifteenth-century mercer Richard (Dick) Whittington, seventeenth-century Sir John Morden, an East India and Levant trader, and ironmonger Sir Robert Geffrye, whose will was proved in 1704. The seventeenth-century haberdasher William Jones built

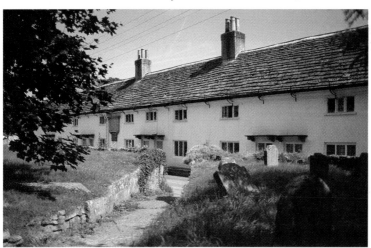

The almshouses in Newland (Gloucestershire), built by William Jones, 'Citizen and Haberdasher of London', who was born in the village and who also built almshouses and a school in Monmouth.

13

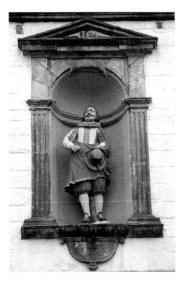

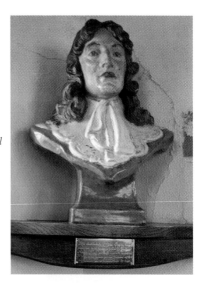

Left: *The statue of John Cowane above the main entrance of his hospital in Stirling.*

Right: *A ceramic bust of Robert Parker, founder of Waddington Hospital (Lancashire) in c.1700, which can be seen in the chapel.*

cottages in Newland (Gloucestershire) and Monmouth, and the wealthy merchant and money scrivener Sir William Turner built his splendid foundation in Kirkleatham (Yorkshire), also in the seventeenth century. In Stirling Robert Spittal, tailor to King James IV, built almshouses in the early sixteenth century, followed a century later by John Cowane's Hospital for 'decayed gild breither'.

Foreign donors included the Spanish-born Balthazar Sanchez, 'first… comfit maker… of all that professe that trade in this kingdom', who settled in London in 1554, Robert Stile, a merchant from Amsterdam who in 1680 built the almshouses bearing his name in Wantage (Oxfordshire), the Dutch Ambassador Sir Noel de Caron, who founded almshouses in Vauxhall (London) in 1623, and

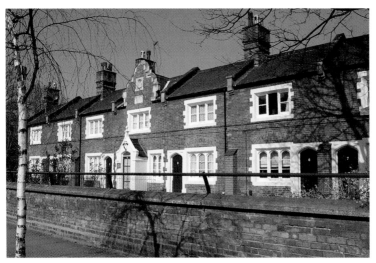

Caron's Homes were established by the Dutch Ambassador Sir Noel de Caron in the Wandsworth Road, Vauxhall (London), from where they were transferred to Fentiman Road, Lambeth (London).

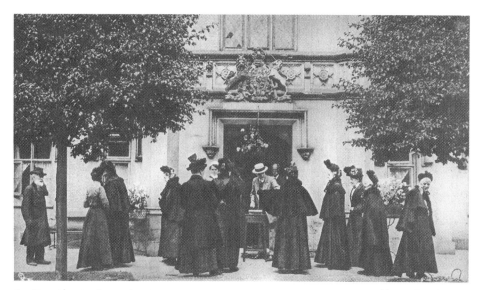

the Russian Ambassador Count Woronzow, who in 1836 left £500 towards almshouses in St John's Wood (London).

Many benefactors were women. The fourteenth-century Trinity Hospital in Salisbury is attributed to Agnes Bottenham, a reformed brothel keeper. In Yorkshire Thornton-le-Dale has Lady Lumley's Almshouses (1656), Beverley Ann Routh's Hospital (1750), and York the Ann Middleton Hospital (1659) and Mary Wandesford House (1725). In Machynlleth (Powys) almshouses were provided by Viscountess Vane (1868), and in Dumfries Mary Carruthers left

Above: Pay day at the Woronzow or St Marylebone Almshouses in St John's Wood (London) in Edwardian times.

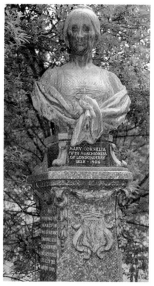

Above: *This long row of almshouses in Thornton-le-Dale (Yorkshire) was founded by Lady Lumley in 1656, together with the school next door. Benefactors often provided for both the young and the old.*

Right: *Bust of Mary Cornelia, Viscountess Vane, later fifth Marchioness of Londonderry. It can be found in the gardens of the former home of the Marchioness, Plas Machynlleth, now the location of 'Celtica', an exhibition devoted to the Celts. She built almshouses in Machynlleth.*

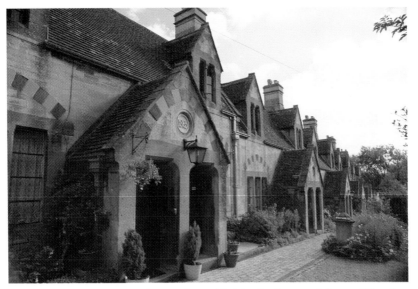

In Winchcombe (Gloucestershire) Emma Dent of Sudeley Castle engaged George Gilbert Scott to build the charming almshouses known as Dent's Terrace in 1865.

Almsmen standing outside St John's Hospital, Lichfield, c.1900. They obviously did not have to wear a uniform.

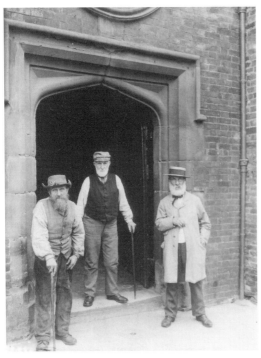

funds for cottages for 'ten or fewer lame or blind women' (1829). Frances Geering's almshouses in Harwell (Oxfordshire) and Lady Catherine Herbert's almshouses in Preston upon the Weald Moors (Shropshire) date from the early eighteenth century, whilst Emma Dent's cottages in Winchcombe and Lady Fitz-hardinghe's modest development in Berkeley (both Gloucestershire) are from the nineteenth century. In the twentieth century homes for retired Nottinghamshire miners were built with money left by Mary Hardstaff, whilst Jane Maddock provided a row of cottages in Alsager (Cheshire) and Maria Laetitia Kempe Homeyard the Homeyard Homes for widows of Cornish seamen in Veryan (Cornwall), using money derived from the manufacture of the patent medicine Liquafruta.

Donors usually had clear ideas about who should benefit from their magnanimity. Only the deserving

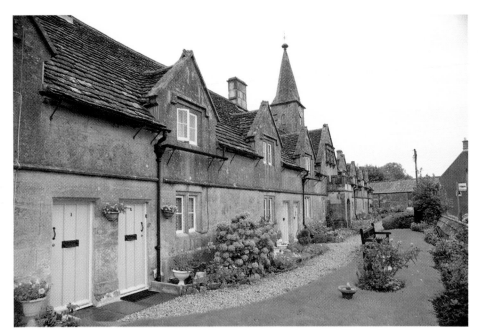

The Crispe Almshouses in Marshfield (Gloucestershire), with their pretty gardens. Note the chapel in the centre.

were admitted. The founder of the seventeenth-century Crispe Almshouses in Marshfield (Gloucestershire) required applicants to be 'Good, Quiet, Sober and [of] Honest Conversation', whilst the seventeenth-century Blechynden's Almshouses in Salisbury admitted only widows 'who had been industrious'. The ladies at Trinity Hospital (c.1614), Castle Rising (Norfolk), were to be 'able to read, if such a one be had … no common beggar, harlot, scold,

In 1682 Mary Blechynden left just over £566 to build Blechynden's Almshouses in Salisbury for six poor widows and to keep them in repair 'for ever'.

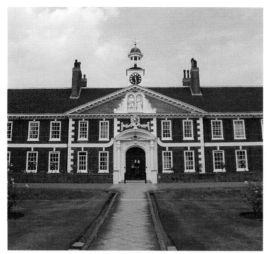

Morden College in Blackheath (London) was built by Sir John Morden for 'forty decay'd merchants', who, according to Daniel Defoe, received forty shillings per year 'with coals, a gown (and servants to look after their apartments) and many other conveniences'. The statues are of Sir John and Lady Morden.

drunkard, haunter of taverns, inns and alehouses'. The rules of Morden College (1695), London, stated that 'common swearers, drunkards, quarrelsome, debauched, or disorderly persons ... shall be immediately expelled and put out for ever'.

Requirements regarding gender, marital status and age at admission varied, as, after the Reformation, did those stipulating religious affiliation. The Hospital of St Cross (c.1135), Winchester, was for 'Thirteen poor men, feeble and so reduced in strength that they can scarcely, or not at all, support themselves without other aid'. Aubrey's Almshouses (1630) in Hereford were for 'poor widows and single women of good character and not less than sixty years of age'. In Blewbury (Oxfordshire) the tiny eighteenth-century Bacon Almshouse was for the oldest and most deserving man of the parish and the equally small nineteenth-century Phillips Almshouse was for the second oldest and most deserving man. Applicants for Ann Bearpacker's Almshouses (1818) in Wotton-under-Edge (Gloucestershire), the Chavasse Almshouses (1886) in Walsall and Frances Sanders' Almshouses (1860) in Owston Ferry (Lincolnshire) were required to be members of the Church of England, as were those for the Ash

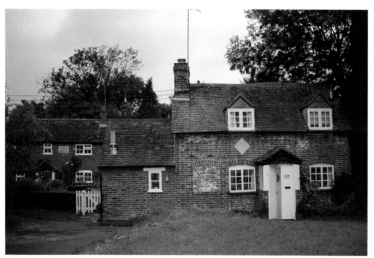

Phillips Almshouse on the left and Bacon Almshouse on the right – now with modern extensions – were built for the two most deserving men in the village of Blewbury (Oxfordshire). Now deserving women may also apply.

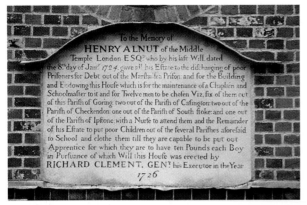

To the Memory of
HENRY ALNUT of the Middle
Temple London ESQ^r who by his laſt Will, dated
the 8th day of Jan^y 1724, gave all his Eſtate to the diſcharging of poor
Priſoners for Debt out of the Marſhalſea Priſon: and for the Building
and Endowing this Houſe which is for the maintenance of a Chaplain and
Schoolmaſter to it and for Twelve men to be choſen Viz, ſix of them out
of this Pariſh of Goring: two out of the Pariſh of Caſington: two out of the
Pariſh of Checkendon: one out of the Pariſh of South ſtoke: and one out
of the Pariſh of Ipſtone; with a Nurſe to attend them and the Remainder
of his Eſtate to put poor Children out of the ſeveral Pariſhes aforeſaid
to School and clothe them till they are capable to be put out
Apprentice for which they are to have ten Pounds each Boy
in Purſuance of which Will this Houſe was erected by
RICHARD CLEMENT, GEN^t his Executor in the Year
1726

In Goring Heath (Oxfordshire) Henry Alnut made sure that some of the rules of his almshouse became public knowledge (possibly to make sure that they were kept). This plaque can be found above the central chapel.

Almshouses (c.1676) in Leek, who should be 'poor widows or maidens of sixty years or upward' and 'constant comers to church'. Colton's Hospital (1717) in York was for 'destitute widows and spinsters', preferably of the Unitarian faith. In Coleford (Gloucestershire) members of the Baptist Church were favoured, and in Market Rasen (Lincolnshire) David Young provided almshouses for Catholics in 1845. Frow's Charity (1926) in Gainsborough prefers members of the United Reformed Church.

Many benefactors wished their charities to be for people from a particular area. In 1724 Henry Alnut stipulated that his almshouses in Goring Heath (Oxfordshire) were for twelve men, 'six of them out of this Parish of Goring: two out of the Parish of Casington: two out of the Parish of Checkendon: one out of the Parish of South Stoke: and one out of the Parish of Ipstone: with a Nurse to attend them'. The almshouses founded in 1666 by Bishop Barrow in St Asaph (Denbighshire) were designated for four widows each from the parishes of Cefn Meiriadog and Llanerch. Thomas Guy (founder also of the London hospital that takes his name) specifically

The Barrow Almshouses in St Asaph (Denbighshire), built in 1666 by Bishop Barrow following his donation of £12, were rebuilt in 1795. The main entrance in the centre of the building led to a narrow yard from where the eight almswomen could all reach their own front doors. It is now a restaurant.

The gateway, dated 1668, leading to Wright's Almshouses in Nantwich (Cheshire). A native of the town, Sir Edmund Wright became a wealthy grocer and Lord Mayor of London. The almshouses were completely reconstructed here, having been moved from another part of the town.

excluded the citizens of Tamworth from the almshouses he established in that town in 1673, offended at their refusal to re-elect him as their Member of Parliament. He allowed only those coming from certain villages and hamlets to apply.

In 1634 Sir Edward Wright donated almshouses to Nantwich, stipulating that preference should be given to any man sharing his surname. Similarly in Market Deeping (Lincolnshire) the trustees of the almshouses built with money left by Mary Ann Scotney in 1876–7 were asked to favour anyone in direct line of descent from the donor.

Some charities were founded for people from specific occupational backgrounds. In 1711 Archibald Harper established almshouses in Wells for 'five poor decayed woolcombers' who had served their apprenticeship in that city, and in 1726 Labray's Hospital was founded in Nottingham for six poor framework knitters. In Ampthill (Bedfordshire) John Crosse built Oxford Hospital (1697) for retired servants of Oxford colleges, whilst Banks' Almshouses (1726) in Revesby (Lincolnshire) were for 'ten poor decayed farmers come to poverty by loss of cattle'. In 1695 John

Oxford Hospital in Ampthill (Bedfordshire).

Overlooking the burial ground of the Church of St Mael and St Sulien in Corwen (Denbighshire), The College was established in 1750 for six widows of clergymen of the Church of England who had worked in the county of Merioneth. It is now used as a retreat centre.

Below: The Bromley and Sheppard's Colleges, Bromley. The seventeenth-century Bromley College was founded by Bishop Warner for 'twentie poore widowes (of orthodoxe and loyall clergymen)'. Finding that a daughter looking after her mother in the almshouse would be made homeless after her mother's death, a Mrs Sheppard donated money in 1840 for a college, bearing her name, to be made available to these unfortunate people.

Edmanson left £1200 for the relief of 'decayed sailmakers and their widows' in London, and in 1714 William Huntington left £740 for almshouses and a chapel for ship-carpenters' widows in West Stockwith (Nottinghamshire). In the early twentieth century three directors of the Sheffield Brewery Company established the Ellen Carter Almshouses in Totley (Yorkshire) for retired brewery workers.

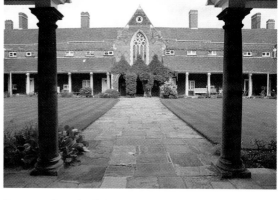

Clergymen's widows and daughters were cared for in Newton's College (1800), Lichfield, the Matrons' College (1682) in Salisbury, The College (1750) in Corwen (Denbighshire), the Clergymen's Widows' Almshouses (1727) in Mapleton (Derbyshire), Bromley and Sheppard's Colleges (1673/4 and the early nineteenth century) in Bromley and Sir Edmund Turnor's Almshouses (1697) in Wragby (Lincolnshire).

Many ports have interesting almshouses, built for those retired from seafaring trades. In London, as well as the Royal Naval College in Greenwich, there are the former Trinity Almshouses in Mile End, established in 1695 for '28

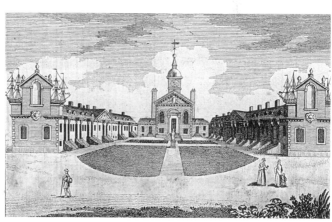

The ground for the Trinity Almshouses in the Mile End Road (London) was given by Captain Henry Mudd, whose tomb can be found in St Dunstan's Churchyard nearby.

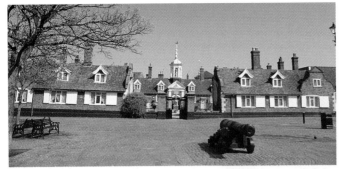

The Fishermen's Hospital in Great Yarmouth was founded by the corporation of the town in 1702. The retired fishermen could bring their wives, but if they became widowed they could 'not marry out of the said Hospital without approbation of the Committee'.

Right: *The Lord Leycester Hospital in Warwick was founded in 1571 by Robert Dudley, Earl of Leicester, for aged or disabled soldiers and their wives. It is still used for its original purpose.*

Below: *Coningsby Hospital in Hereford was founded in 1614 by Sir Thomas Coningsby for 'a Chapleyne and eleven poore ould servitors that have been souldiers, mariners, or serving men … the Chapleyne to be a Graduate in the University of Oxford and a preacher well read'.*

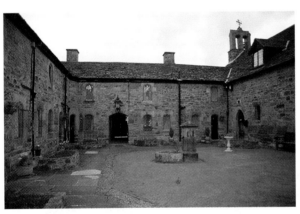

decay'd Masters & Comanders of Ships, or ye Widows of such'. Whitby has its Seamen's Hospital (c.1670; rebuilt in 1842 by George Gilbert Scott), Scarborough the Wilson's Mariners' Homes (1836); Newcastle upon Tyne has the eighteenth-century Keelmen's Hospital and fifteenth-century Trinity House, Great Yarmouth the Fishermen's Hospital (1702), Bristol the seventeenth-century Merchant Venturers' Almshouses and Chatham the Sir John Hawkins Hospital for mariners and shipwrights (1594).

Retired members of the armed forces may find shelter in the Royal Hospital (1682), Chelsea, the Lord Leycester Hospital (1571), Warwick, Coningsby Hospital (c.1614), Hereford, and the Scottish Veterans Housing Association Limited (1910) in Edinburgh and Dundee. Early in the twentieth century Colonel Henry Burton built almshouses in Monmouth, Newport and Caerwent (Monmouthshire) as 'a last resort for ex-volunteers'.

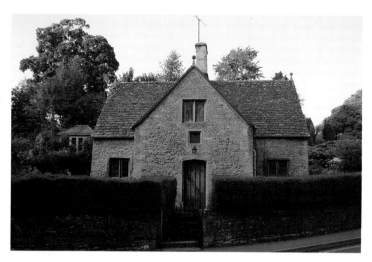

The seventeenth-century foundation of the Jesus Almshouse in Bibury (Gloucestershire), mostly rebuilt in the early twentieth century, was intended for a master and three co-brethren. Its founder was Hugh Westwood, a yeoman farmer. It later became a private house.

The buildings

Almshouses exist in a variety of sizes and styles, depending on the wealth of the foundation and the fashion of the period in which they were built. They range from small, single cottages – as can be found in the churchyard of Blewbury (Oxfordshire) – to the miniature village formed by the Tradesmen's Homes (1856) in Bradford. Early almshouses were constructed by unknown builders, for example the 150 foot (46 metre) long row of fifteenth-century half-timbered cottages in Stratford-upon-Avon, provided by the Guild of the Holy Cross; later ones might have had a well-known architect involved, as at Godstone (Surrey), where in 1872 Sir George Gilbert Scott designed the beautiful group of eight houses, warden's house and chapel known as St Mary's Homes.

The Bradford Tradesmen's Homes were established for retired tradesmen of the city and their dependants who had fallen on hard times. The foundation stone was laid by Sir Titus Salt (who built his own set of almshouses in nearby Saltaire), who donated two thousand guineas.

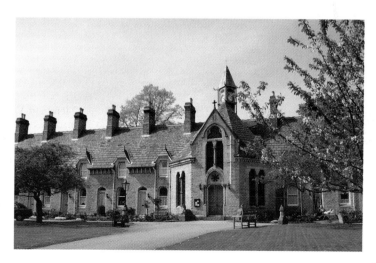

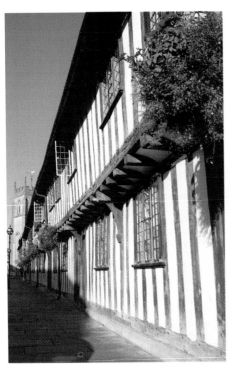

This picturesque row of almshouses in Stratford-upon-Avon was built c.1427 by the Guild of the Holy Cross. It is thought to be the oldest surviving building in the town.

Many almshouses form rows, though some consist of no more than two or three houses. Potterell's Almshouses (1810) in Duffield (Derbyshire), the former Petworth Estate almshouses (1840) in Tillington (Sussex) and the Mrs John Aston Watkins Almshouses (c.1928) in Kendal each consist of two dwellings. King's Bromley (Staffordshire) and East Bilney (Norfolk) have three nineteenth-century cottages each, and Much Wenlock (Shropshire) has four eighteenth-century buildings. The four cottages forming the Yorke Almshouses in Forthampton (Gloucestershire) were designed in 1863–5 by William Burges, the architect associated with Cardiff Castle. In contrast, the seventeenth-century Ingram's Hospital in York comprises eleven bays, broken up by a central tower, while the nineteenth-century buildings of Seckford Hospital, Woodbridge (Suffolk), almost fill

The Earl of Egremont of nearby Petworth House (Sussex) built these two cottages, now a single private house, in 1840 as estate almshouses.

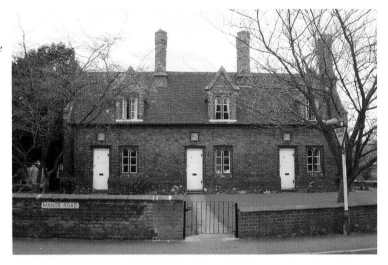

The Lane Almshouses in King's Bromley (Staffordshire) were built by the local Lane family in the mid nineteenth century.

one side of a long road. In Newcastle upon Tyne Holy Jesus Hospital (*c.*1682) incorporates an arcade at street level. In St Germans (Cornwall) the Moyle Almshouses (1583) offer dwellings on two levels. The Sir Baptist Hicks Almshouses (1612) in Chipping Campden (Gloucestershire) are approached by a set of steps leading to a wide footpath that serves as a forecourt. In Cossall (Nottinghamshire) the seventeenth-century Willoughby Almshouses, situated high above the road, are reached by steps up through two walls at different levels.

In Abingdon an irregular square is formed by the parish church, the rows of the fifteenth-century Long Alley Almshouses, and the eighteenth-century Twitty's and Brick Alley Almshouses. Another interesting group can be found in Wells. Here the fifteenth-century

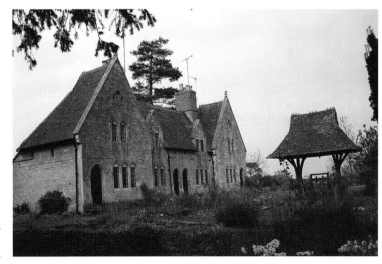

The Yorke Almshouses in Forthampton (Gloucestershire), situated behind the church, were built for the Yorke family by William Burges in 1863–5.

Holy Jesus Hospital in Newcastle upon Tyr built by 'the Mayor and Burgesses Newcastle upon Tyne for the maintenanc subtenation and relief of poor impotent peop being Freemen and Freemen's widows or th sons and daughters that have never be married, for ever'.

Below: Water was brought via a conduit the now defunct communal pump of the S Baptist Hicks Almshouses in Chippir Campden (Gloucestershire).

The Moyle Almshouses in St Germans (Cornwall), on two levels, were built in 1583 for twelve poor people.

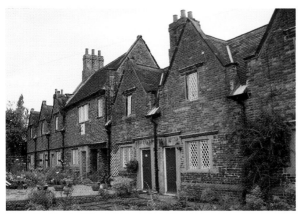

In Cossall (Nottinghamshire) the Willough Almshouses of 1685 feature a centre with saddleback roof. One nineteenth-centu pensioner had taken part in the Battle Waterloo. D. H. Lawrence used the villag which he called 'Cossethay', as the setting f much of his novel 'The Rainbow' and featured the almshouses themselves in 'T White Peacock'.

26

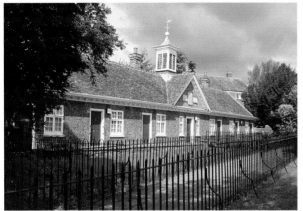

Twitty's Almshouses in Abingdon, which provide one side of the square shared with St Helen's Church, Brick Alley Almshouses and Long Alley Almshouses, date from 1707.

Right: *The Jacobean stone seats with canopies, overlooking St Cuthbert's churchyard in Wells, belong to Bricke's Almshouses, which are part of a striking formation of buildings along with Bubwith's, Willes' and Still's Almshouses.*

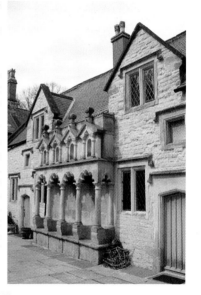

Bubwith Almshouses are flanked by the seventeenth-century Bricke's Almshouses, with their charming set of Jacobean canopied stone seats, and by Still's Almshouses and the eighteenth-century Willes' Almshouses. In Nantwich the seventeenth-century Wright's Almshouses were moved next to the eighteenth-century Crewe Almshouses, to which the late-twentieth-century Hope Almshouses have been added. In Wotton-under-Edge (Gloucestershire) the courtyard and chapel behind the façade of Perry's Almshouses (1638) are shared with the Dawes Almshouses and the General Hospital, both dating from 1723. In the capital the City of London Freemen's Houses (1832) in Brixton were joined in the 1880s by the relocated seventeenth-century Robert Rogers' Almshouses and Gresham's Almshouses.

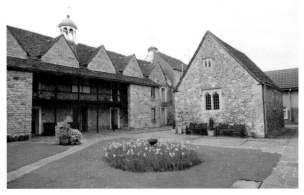

In Wotton-under-Edge (Gloucestershire), Perry's Almshouses share their courtyard and chapel with Dawes Almshouses and the General Hospital. An inscription over the doorway on the courtyard side details the rules of the almshouse.

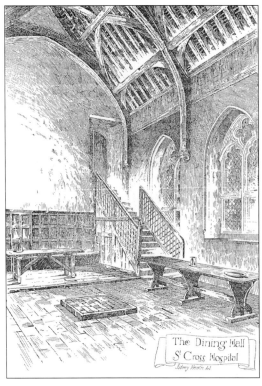

An early-twentieth-century drawing (by Sidney Heath) of the fourteenth-century Brethren's Hall of the Hospital of St Cross in Winchester. The heating was provided by an open fire in the centre of the room.

The Dining Hall
St Cross Hospital
Sidney Heath del.

Many almshouses are built around a courtyard, reminiscent of monastic cloisters and college quadrangles, and may include a chapel and master's house. The earliest example can be found in Winchester, where the buildings of the twelfth-century Hospital of St Cross include an imposing gateway, a Norman church, a fourteenth-century kitchen and Brethren's Hall, as well as the Master's Office and the Porter's Lodge, where, uniquely, the Wayfarer's Dole of 'a morsel of bread and a horn of beer' is offered to visitors. In Ewelme (Oxfordshire) the courtyard built by the Duke and Duchess of Suffolk in 1437 is surrounded by a covered arcade from which steps lead into the parish church. The Charterhouse in London, founded by Thomas Sutton in 1611 on the ruins of a former Carthusian priory, has three courtyards. The courtyards of both Whitgift's Hospital (1596) in Croydon and Abbot's Hospital (1619) in Guildford are entered via a gateway with the founder's coat of arms. The latter has an alms box inside the entrance.

The courtyard of the almshouses in Ewelme (Oxfordshire). A covered staircase behind the exit on the right leads into the church, giving the pensioners some protection from bad weather. The pump makes a focal point.

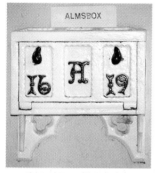

The alms box inside the main entrance of Abbot's Hospital in Guildford.

Below: *The narrow courtyard of Ford's Hospital, Coventry. The inscription states that at one time a couple received 7½d per week; however, whereas a husband losing his wife could keep the full amount a widow would receive only half of this.*

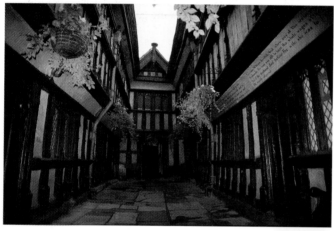

One of the smallest courtyards belongs to the half-timbered Ford's Hospital (c.1509) in Coventry, where the overhang allows for very little sky to be visible. Not much larger is the enclosure of Trinity Hospital (rebuilt c.1702) in Salisbury with its little chapel. Coningsby Hospital (c.1614) in Hereford and Sexey's Hospital (1638) in Bruton (Somerset) also have chapels in their courtyards, and the inner area of Stile's Almshouses (1680) in Wantage (Oxfordshire) is reached via a passageway partly paved with the knuckle-bones of sheep. In Lambourn (Berkshire) one must pass through a monumental gateway, rebuilt in 1852, to gain access to the courtyard of the Estbury's Almshouses (1502). The hospital founded in 1711 by Rebecca Wilkins in Ravenstone (Leicestershire) is unusual in having its doorways facing outwards rather than towards the quadrangle.

The passage leading to the courtyard of Stile's Almshouses in Wantage. Note the sheep's knuckle-bones.

The hospital founded by Rebecca Wilkins in Ravenstone (Leicestershire) in 1711 in memory of her son John, with its unusual outward-facing doorways.

Right: *The Lady Catherine Herbert Hospital in Preston upon the Weald Moors (Shropshire), built in 1716, is an example of Georgian almshouse architecture on a magnificent scale. It is approached via two lodges with giant Tuscan pilasters. The hall in the centre has a square lantern. It is no longer used for its original purpose.*

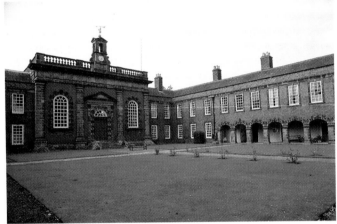

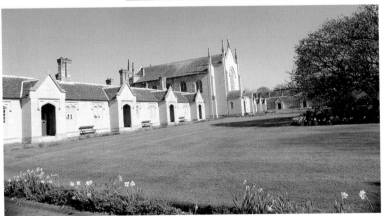

The Shrewsbury Hospital in Sheffield, established in 1673, was rebuilt in 1823, providing thirty-five almshouses and accommodation for a chaplain and a nurse, as well as a chapel.

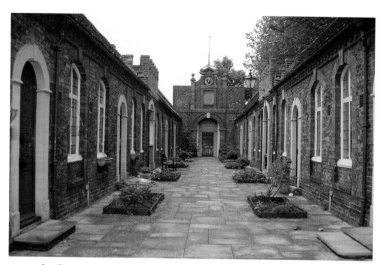

Benjamin Tomkins built his almshouses in Abingdon in 1733. They are arranged along two sides of a courtyard, at the end of which an arched doorway in a gabled wall (which has an inscription and a clock) leads to a garden.

Some almshouses are built around three sides of a plot, often with a chapel at the far end, and some have magnificent gates. Examples on a large scale are the Sir William Turner Hospital (1676) in Kirkleatham (Yorkshire), the hospital founded in Etwall (Derbyshire) in 1550 by Sir John Port, the Lady Catherine Herbert Hospital (1716) in Preston upon the Weald Moors (Shropshire), the Mary Warner Homes (1736) in Boyton (Suffolk), the Sir William Fraser Homes (1848) in Edinburgh, Waddington Hospital (1680) in Lancashire, the Shrewsbury Hospital (1673) in Sheffield and Laslett's Almshouses (1868) in Worcester. Smaller foundations of this type include Tomkins' Almshouses (1733), Abingdon, Trinity Almshouses (1695), Mile End (London), the Hospital of Sir John Hawkins (1594), Chatham, the Lady Katherine Leveson Hospital (1679) in Temple Balsall (Warwickshire) and Berkeley Hospital (1697), Worcester. Foster's Almshouses (*c.*1481) in Bristol were rebuilt piecemeal in the second half of the nineteenth century.

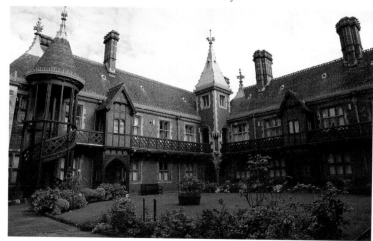

The style of Foster's Almshouses in Bristol is reminiscent of the medieval Hôtel-Dieu in Beaune, France.

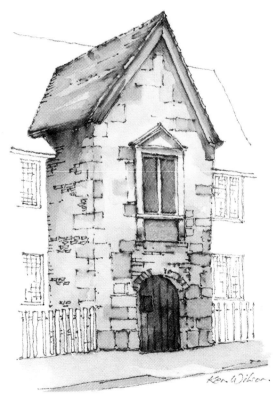

The sixteenth-century building of Dr Milley's Hospital in Lichfield has a projecting main entrance with individual units behind.

In some charitable institutions the individual units are situated behind a main entrance. In Lichfield the sixteenth-century Dr Milley's Hospital is entered via a large doorway into the projecting hall, with a chapel above. Behind these run corridors on two levels, along which each almswoman has her own front door. In Ludlow Hosyer's Almshouses (1486) provide access to individual units via newel stairs at the back of the building, which run from the cellars to the attics and corridors. The Blue House (1726) in Frome, which, not unusually, combined almshouses with a school (indicated by the statues of an elderly lady and a bluecoat boy), has one main entrance, as have Moorheads Hospital (1753), Dumfries, Sir

The façade of the Blue House in Frome, built in 1726, has a statue of an elderly woman in a niche above the main door.

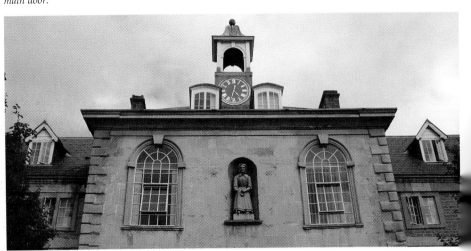

In Bunny (Nottinghamshire) the almshouses, still in existence, shared space with a school in a single building dating from 1700.

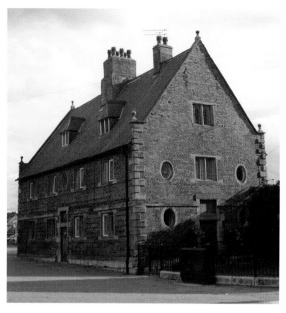

Thomas Parkyns's Almshouses (1700) in Bunny (Nottinghamshire), Cowane's Hospital (1637) in Stirling, Sloswicke's Hospital (rebuilt 1806) in East Retford and Hutcheson's Hospital (rebuilt 1805) in Glasgow. The main entrance of the Barrow Almshouses (rebuilt 1795) in St Asaph (Denbighshire) and The College (1750), Corwen (Denbighshire), led to separate doors in the courtyard behind.

Sloswicke's Hospital in East Retford is another example of a single house with a main doorway.

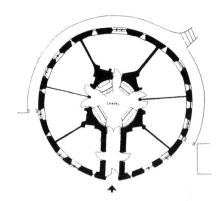

Plan of the round building belonging to Beamsley Hospital near Skipton, illustrated on the front cover. Seven of the thirteen residents lived in the rooms surrounding the central chapel and another six in a row of cottages in front of this unique structure.

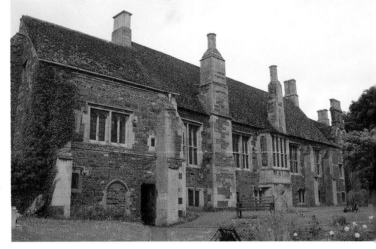

The Bede House in Lyddington (Rutland) is now a museum belonging to English Heritage, which gives a fascinating insight into the life of the alms people who occupied the building until the 1930s.

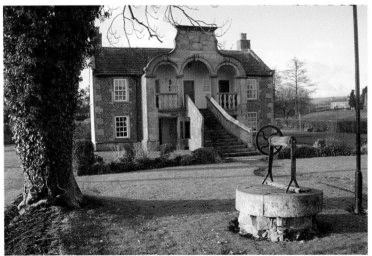

The Shireburn Almshouses in Stidd-under-Longridge (Lancashire) were built in 1728 for five almswomen and the school mistress. As in many almshouse grounds the communal pump is still there.

The Gascoigne Almshouses in Aberford (Yorkshire) were built by two sisters in memory of their father. There was a dining room at one end and a chapel at the other, with a clock-tower in the middle. The matron had her own cottage in the grounds. The buildings are now used for offices.

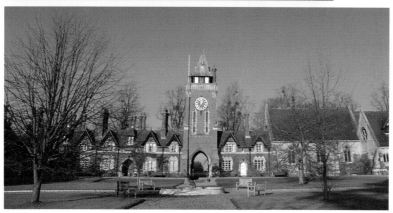

The Beauchamp Almshouses in Newland (Worcestershire), built 1862–4, are arranged around a spacious green. The church has a window in the west wall, which allowed sick pensioners to follow the services from their beds.

Some almshouses call for special attention. Beamsley Hospital (1593) near Skipton is made up of a circular building, containing seven rooms around a central chapel, and a row of cottages. In Lyddington (Rutland) the Bede House (1600) was fashioned out of the remains of a former bishop's palace, and in Stidd-under-Longridge (Lancashire) the upper floor of the two-storey Shireburn Almshouses (1728) is reached via a wide external staircase, leading to a balcony underneath three arches with an unusual gable above. In Hurst Green (Lancashire) an earlier Shireburn Almshouse (1706) has an imposing flight of steps leading to a pedimented former chapel, topped with urns. Equally striking is the architecture of Fountains Hospital (1721) in Linton (Yorkshire) and the Gascoigne Almshouses (1844) in Aberford (Yorkshire). In Newland (Worcestershire) the large site of the Beauchamp Almshouses (1862–4) includes a gateway with a clock-tower and a highly decorated church with an oriel window, which allowed sick patients to attend services from their beds.

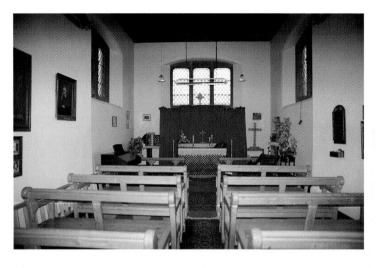

Life in the almshouses

While assured of shelter, alms people were generally governed by strict rules. These were often enforced by a master, chaplain, lecturer, reader, matron or mother (or a combination of some of these) who were – and are – accountable to the trustees. To help with the running of the institution an alms person might be appointed as

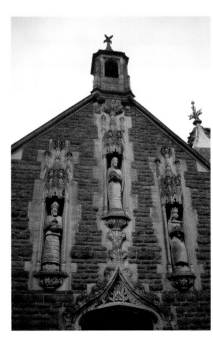

an overseer, as is the case in Trinity Hospital, West Retford, or keeper of the keys, as happened in the Fishermen's Hospital of Great Yarmouth. In Hosyer's Almshouses, Ludlow, a bellman was appointed to summon the pensioners to chapel, and in the Crisp Almshouses, Marshfield (Gloucestershire), an almsman was paid to read prayers in the chapel and to 'draw up the clock each week'.

Regular prayer was – and in some cases is – of great importance. In Trinity Hospital, Clun (Shropshire), the men were told to pray at least three times daily, 'devoutly upon your knees in your chamber'. The hospital at Waddington (Lancashire) required that 'all tenn widdowes give their constant attendance att the said prayers'. In pre-Reformation days founders would stipulate that prayers be said for their souls, as did James Terumber of Trowbridge and William Ford in Coventry. The brothers and sisters of Trinity Hospital, Guildford, walked daily to chapel wearing their blue uniforms.

The original early-sixteenth-century chapel, unusually dedicated to the 'Three Kings of Cologne', belonging to Foster's Almshouses in Bristol. The statues are modern.

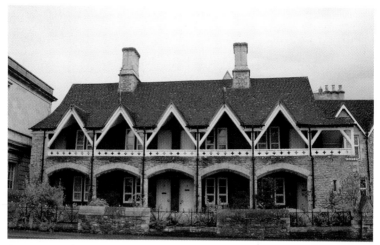

The almshouses, rebuilt in 1861, founded by James Terumber in fifteenth-century Trowbridge. The alms people, governed by a priest, were to pray twice daily for the souls of the founder and his wives Joan and Alice.

Many foundations provided clothing. Richard Whittington specified that gowns should be 'derke and broune of Color and not staring ne blasing and of esy prised [reasonably priced] cloth according to their degre [status in life]'. In Bath St Catherine's Hospital was known as 'the Black Alms' and St John's Hospital as 'the Blue Alms' because of the colour of the gowns worn at each institution. At St Nicholas' Hospital, Glasgow, the pensioners wore white, receiving a pair of double-soled shoes on the first day of every January.

Though outfits changed over time, they have always been old-fashioned. In the nineteenth and twentieth

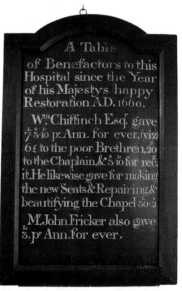

List of benefactors to Trinity Hospital, Salisbury. Over the years almshouses often received additional gifts as the original sums invested in them became depleted.

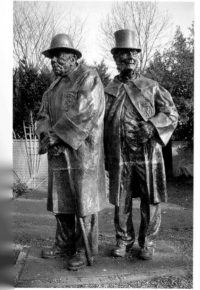

A statue of two almsmen, Joc Weale and Billie Cantle, in the grounds of Trinity Hospital, Clun (Shropshire). It shows the uniform worn by the men, including the badge with the Earl of Northampton's coat of arms.

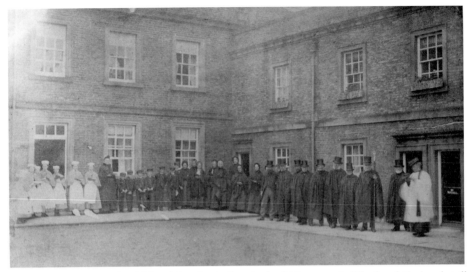

Alms people (including the children belonging to the school, which was part of the foundation) and staff on Founder's Day outside Sir William Turner's Hospital in Kirkleatham (Yorkshire) in the early twentieth century.

centuries men's dress would usually include boots and top hats, as at the Trinity Hospitals in Clun (Shropshire) and Greenwich, Browne's Hospital, Stamford, Sir William Turner's Hospital, Kirkleatham (Yorkshire), and Jesus Hospital, Rothwell (Northamptonshire), where the men had separate uniforms for weekdays and Sundays. At the Hospital of St Cross, Winchester, brothers of the original foundation wear black gowns with a silver cross and members of the later Order of Noble Poverty wear red gowns with a cardinal's badge. Soft hats, or trenchers, have replaced

Life in an almshouse may have helped some people reach a great age. In Rolleston (Staffordshire) the trustees of the almshouses paid for a tombstone for Thomas Hampson, who died at the age of 101.

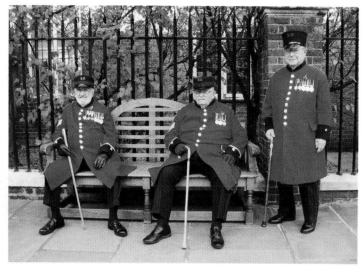

Three pensioners of the Royal Hospital in Chelsea.

top hats. Military-style uniforms are still worn by the pensioners of the Royal Hospital, Chelsea.

Badges, buckles or buttons with the founder's coat of arms were often part of an outfit, as was – and in some instances still is – the case in the Lord Leycester Hospital, Warwick, Richard Whittington's College, London, Carre's Hospital, Sleaford (Lincolnshire), the Almshouse of SS. John in Sherborne (Dorset), the three Trinity Hospitals established by Henry Howard in Clun (Shropshire), Greenwich and Castle Rising (Norfolk), Hall's Almshouses in Bradford-on-Avon (Wiltshire) and Long Alley Almshouses, Abingdon.

Often the initials of the founder were embroidered on cloaks or gowns. In Godalming Richard Wyatt's widow stipulated that the almsmen should wear 'a coate made of cloth with two letters that is to

Eighteenth-century Trinity Hospital badges, worn by the residents of the Greenwich foundation, showing the Earl of Northampton's coat of arms.

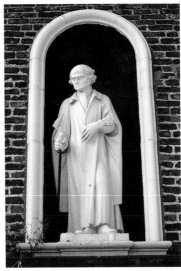

The figures of an almswoman (far left) and an almsman (left) in the façade of Sir William Turner's Hospital in Kirkleatham (Yorkshire), founded in 1676.

Right: *Mrs Kath Weller, one of the dames living in the Hospital of Lady Katherine Leveson in Temple Balsall (Warwickshire), displaying a combination of the former summer and winter uniform.*

Below: *The sisters of Trinity Hospital in Castle Rising (Norfolk), dress for church in red cloaks with badges, and soft black hats. The conical hat is kept for special occasions.*

say R. W. for my said late husband's name in the bosomes'. At Elizabeth Ash's almshouses in Leek, the women received a new gown of violet cloth embroidered with the letters E.A. every two years, while the dames of the Lady Katherine Leveson Hospital in Temple Balsall (Warwickshire) wore grey dresses with the initials K.L. and blue collars and cuffs, with red and black checked shawls and black bonnets in winter and white and black checked shawls and straw bonnets in summer. The ladies of Trinity Hospital, Castle Rising (Norfolk), wear traditional red cloaks to church but the heavy conical hats, reserved only for special occasions, are usually replaced with something lighter. Where uniforms exist(ed) the wearing of them would be compulsory, on pain of expulsion. However, any widow in Sir Thomas Parkyns's Almshouses in Bunny (Nottinghamshire) refusing to have the founder's coat of arms embroidered on her gown would merely lose the garment, with the money saved thereby divided among the other beneficiaries.

The audit room of Browne's Hospital in Stamford, situated above the former infirmary hall. Many almshouses had (or have) such a room, for the feoffees or trustees to meet in.

In addition to clothing, pensioners might receive money, coals, firewood, candles and food. An interior photograph of St Mary's Hospital, Chichester, of 1885 shows bundles of wood on the flat roofs above the rooms. In the sixteenth century the Great Hospital in Norwich provided a diet that included home-produced ale and bread (which must not be coarse), salted fish and hard cheese, whilst Christ's Hospital in Ruthin (Denbighshire) kept 'a dairy of three or four kine' whose milk had to be divided 'amongst the poor of the said hospital', who also received shoes, gowns, fuel and money. Similarly, the alms people living in Sir Baptist Hicks's Almshouses in Chipping Campden (Gloucestershire) received money, a ton of coal and a frieze gown and felt hat every year. In eighteenth-century Temple Balsall (Warwickshire) the dames collected their bread using a path still known as 'The Breadwalk'. An inscription dated 1857 on the façade of the Lovett Almshouses in West Haddon (Northamptonshire) announces that

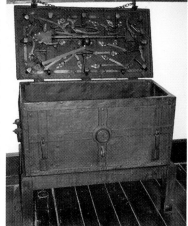

This magnificent muniment chest belongs to Hugh Sexey's Hospital in Bruton (Somerset). Almshouses needed places of safe keeping for their deeds, seals and other valuables.

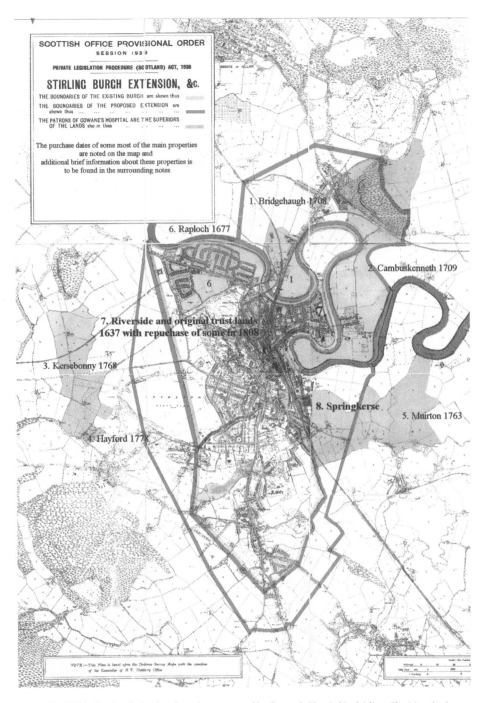

1. Bridgehaugh 1708

6. Raploch 1677

2. Cambuskenneth 1709

7. Riverside and original trust lands
1637 with repuchase of some in 1808

3. Kersebonny 1768

8. Springkerse

5. Muirton 1763

4. Hayford 1778

A map dated 1939, showing the lands, coloured green, owned by Cowane's Hospital in Stirling. Charities, almshouses included, need endowments to survive, and many own land and buildings to give them the income they need.

42

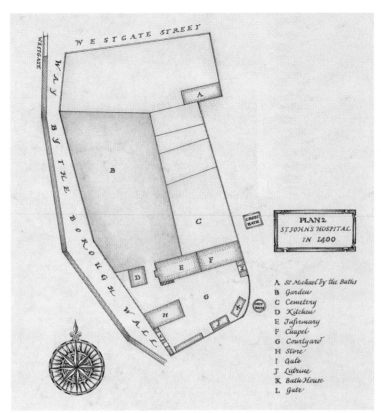

WESTGATE STREET

WESTGATE

WAY BY THE BOROUGH WALL

A

B

C

CROSS BATH

D E F

G

H J K

HOT BATH

PLAN 2.
ST JOHN'S HOSPITAL
IN 1400

A St Michael by the Baths
B Garden
C Cemetery
D Kitchen
E Infirmary
F Chapel
G Courtyard
H Store
I Gate
J Latrine
K Bath House
L Gate

Plan of St John's Hospital, Bath, c.1400, showing the typical arrangement of infirmary hall and chapel. The kitchen is in a separate building as a fire precaution. Some almshouses developed into small estates with a number of outbuildings. This hospital had the advantage of being near the hot springs of Bath.

from the age of sixty-eight residents received three shillings and sixpence. One of the rules of the Gascoigne Almshouses in Aberford (Yorkshire), dated 1st January 1888, states that 'the week's supply of Coffee, Tea, Sugar, Soap, Candles, together with Sixpence in money shall be given out by Matron every Monday morning to each inmate'.

Many almshouses had vegetable plots and, amongst others, pensioners at Hugh Sexey's Hospital, Bruton (Somerset), Trinity Hospital, Castle Rising (Norfolk), and Jesus Hospital, Rothwell (Northamptonshire), regularly have access to home-grown produce.

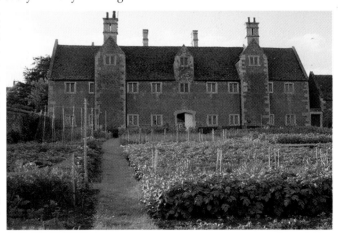

The vegetable garden of Jesus Hospital in Rothwell (Northamptonshire).

An original table and chair as were provided, together with a half-tester bed, for every sister in Trinity Hospital, Castle Rising (Norfolk).

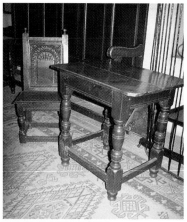

Below: *The eighteenth-century almshouse interior, as recreated at the Geffrye Museum in London.*

Christmas, Easter and Founder's Day might be occasions for special gifts and meals. Thomas Lockerby, founder of the almshouses in Edinburgh named after him, wished his birthday (7th January) to be commemorated every year with the gift of a ton of coals to each resident and a free dinner, 'but only a plain one – a good wholesome Scotch dinner – broth and beef'.

However, entitlements could be lost in fines imposed for bad behaviour. Rules generally covered church attendance, cleanliness, duties to be performed, movement outside the institution, the intake of alcohol, visitors staying overnight and general demeanour. In 1723 a widow was expelled from the Geffrye Almshouses in London

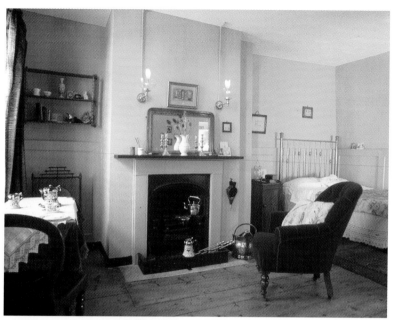

The nineteenth-century almshouse interior (above) and scullery (left), as recreated at the Geffrye Museum in London.

Invitation to the opening of the Lockerby Almshouses (now the Lockerby Cottages) in Edinburgh.

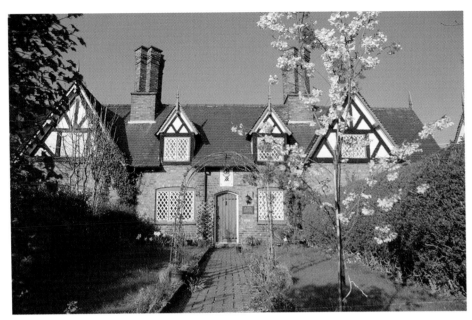

The Wilbraham Almshouses in Nantwich, built in 1870 to replace an earlier set of cottages. From 1804 the almsmen of this foundation received £2 and shoes every year, and a gown and cap every two years.

for harbouring her daughter. In 1666 Joan Sperring was removed from the St Catherine's Almshouses in Bath because of 'very lewd and scurrilous language'. In the eighteenth century a pensioner of the Royal Naval College, Greenwich, was still being punished for drunkenness and swearing at the age of ninety-six. In nineteenth-century Belper two occupants of the Matthew Smith Almshouses fell out and Ann Stafford told a policeman that Eliza Pugh had struck her in the face, making her mouth bleed, saying 'you Old bitch you're Sweeping again'. In the early twentieth century a pensioner living in an almshouse provided by the Aged Christian Friend Society of Scotland in Edinburgh was told to clean her cottage regularly and to remove 'the cat nuisance'. In Nantwich the Widows' Almshouse (which later became the Cheshire Cat pub) at one time housed six widows in three cottages, with individual space being demarcated by lines drawn on the floor. As can be imagined, this led to frequent disputes.

The Great Hospital in Norwich has regularly added new buildings to its foundation.

The modern era

Although times have changed, almshouses have a continuing role to play. While some are now lost, elsewhere new buildings have been erected as independent charities or as additions to existing foundations. In Nantwich a shopkeeper's legacy paid for the Hope Almshouses. The following foundations have all enlarged their housing stock: the Great Hospital, Norwich; Morden College, London; the Burton Homes, Monmouth; the Aged Christian Friend Society of Scotland, Edinburgh; St Mary's Hospital, Chichester; St John's Almshouses, Bristol; Hutchens Almshouses, Paul (Cornwall); the Suffolk Almshouses in Ewelme (Oxfordshire); Ford's and Bond's

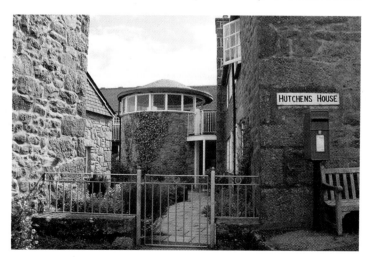

The Hutchens Almshouses in Paul (Cornwall), an eighteenth-century foundation, have been given twentieth-century additions.

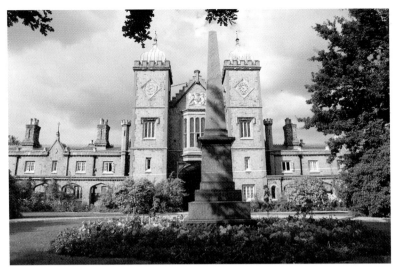

Almshouses in Coventry; the Fence Almshouses and Harry Turner Almshouses in Macclesfield.

Sometimes the need for modern facilities has led to the replacement of old buildings with new ones, either through demolition or by selling off historic sites and establishing new dwellings elsewhere. The latter route was chosen by a number of London charities, which moved outside the capital or to its suburbs. The Company of Watermen and Lightermen of the River Thames, for example, exchanged property in Penge for fifty-one bungalows in Hastings. The Ironmongers moved from Shoreditch to Mottingham (Kent) and then to Hook (Hampshire). The Drapers' Company transferred its almshouses from the City to Tottenham.

New developments on or near original sites include the (Josiah) Mason Cottages, Birmingham, Gilson's Hospital, Morcott (Rutland), the William Jones Almshouses, Monmouth, the Richardson Almshouses, Tewkesbury, William Lunn's Homes, Lichfield, and the Hospital of St John the Evangelist and of St Anne in Oakham.

Where old buildings are kept, updating often leads to a reduction in the number of dwellings as units are

Some new additions are of an artistic nature. This twentieth-century gate graces a much earlier gateway in front of Holy Trinity Hospital, West Retford (Nottinghamshire).

In York, Ann Middleton's Hospital (to the left) became a hotel and the Terry Memorial Homes (on the right) a brass-rubbing centre.

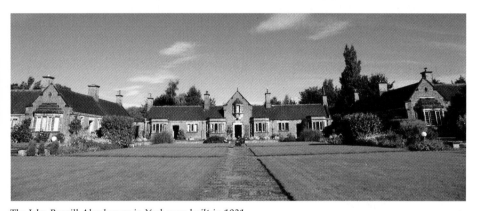

The John Burrill Almshouses in York were built in 1931.

The almshouses in Welshpool (Powys) were built in 1940 with money left by a former mayor of the town, T. J. Evans, as a memorial to his late wife. They were renovated in 2001.

49

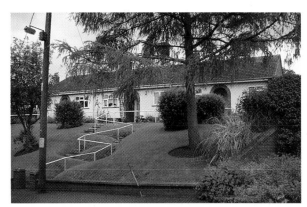

Left: *Three modern almshouses in Longdon (Staffordshire).*

Below: *In Glastonbury the modern almshouses can be seen through the ruined window of the former Hospital of St Mary Magdalene.*

combined to provide larger homes with modern amenities. Alternatively, buildings may be extended at the back. Both methods ensure that the visual aspect is left unharmed.

Often new uses are found for discarded buildings. Some become private homes, as happened in Tillington (Sussex), London, Mapleton (Derbyshire), Bibury (Gloucestershire), Stamford, Machynlleth (Powys), Ashbourne (Derbyshire) and Par (Cornwall). The Geffrye Almshouses, London, and the Bede House, Lyddington (Rutland), have become museums, the almshouses in Sutton Cheney (Leicestershire) a guest house, Bishop Barrow's Almshouses, St Asaph (Denbighshire), a restaurant, and Ann Middleton's Hospital and the Terry Memorial Homes, York, a hotel and a brass-rubbing centre respectively. Beamsley Hospital near Skipton has been turned into a holiday cottage, and the Gascoigne Almshouses, Aberford (Yorkshire), have become offices. The former clergymen's widows' cottages in Corwen (Denbighshire) and the Hospital of St Mary Magdalene, Glastonbury, were turned into spiritual centres by Christian communities. The former Bishop's Hospital in Durham and areas of the former Royal Naval College in Greenwich both became part of the local universities.

In 2003 St John's Hospital, Bath, opened a new almshouse building. Constructed to the highest standards of craftsmanship, incorporating many environmentally friendly features and using the best materials available, this exciting project gives an indication that the future of almshouses is assured.

St John's Hospital, Bath, opened a new building in 2003.

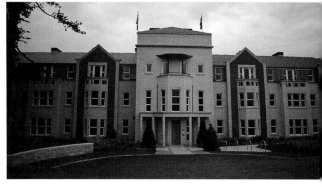

Further reading

General texts

Bailey, Brian. *Almshouses*. Robert Hale, 1988.

Clay, Rotha Mary. *The Mediaeval Hospitals of England*. Frank Cass, 1909.

Cunnington, Phillis, and Lucas, Catherine. *Charity Costumes*. Adam & Charles Black, 1978.

Godfrey, W. H. *The English Almshouse*. Faber & Faber, 1955.

Howson, Brian. *Houses of Noble Poverty*. Bellevue Books, 1993. (Available from the Almshouse Association, Billingbear Lodge, Carters Hill, Wokingham, Berkshire RG40 5RU. Telephone: 01344 452922.)

The Pevsner Architectural Guides (series, various authors): *The Buildings of England, The Buildings of Scotland* and *The Buildings of Wales*. Yale University Press, 2002–3. This series of architectural guides covering different parts of the British Isles was started in 1951 by Nikolaus Pevsner and is continually updated.

Prestcott, Elizabeth. *The English Medieval Hospital c.1050–1640*. B. A. Seaby Ltd, 1992.

Raphael, Mary. *The Romance of English Almshouses*. Mills & Boon, 1926.

Trollope, Anthony. *The Warden*. Penguin Classics, 2004 edition edited by Robin Gilmour.

The Victoria History of the Counties of England (series). Oxford University Press, 1903 onwards. These volumes, covering the history of individual counties, are usually available in local study libraries.

Texts and guides on specific almshouses

Berridge, Clive. *The Almshouses of London*. Ashford, 1987.

Bold, John; Bradbeer, Charlotte; and van der Merwe, Pieter. *Maritime Greenwich*. Collins & Brown, 1999.

Burton, Neil. *The Geffrye Almshouses*. Geffrye Museum, 1979.

Charlton, Christopher, and the Belper Local History Group. *A History of the Matthew Smith Almshouses*. Matthew Smith Trustees, 1991.

Chislet, D. V. *Sackville College*. No date given.

Clayton, Howard. *St John's Hospital, Lichfield*. No date given.

Coventry Church Charities. *As Long As the World Shall Endure*. 1991.

Crust, Linda. *Lincolnshire Almshouses*. Heritage Lincolnshire, 2002. (Available from the Almshouse Association, Billingbear Lodge, Carters Hill, Wokingham, Berkshire RG40 5RU. Telephone: 01344 452922.)

Forward, Raymond. *The Life, Times and Influences of Stephen Hutchens*. No date given.

Gibb, J. H. P. *The Almshouse of SS John, Sherborne*. No date given.

Gooder, Eileen. *Temple Balsall 1150–1870: A Short History*. No date given.

Hillaby, Joe G. *Ledbury: A Medieval Borough*. Logaston Press, 1997.

Hoskins, J. P. *The Hospital of William Browne, Merchant of Stamford, Lincolnshire*. No date given.

Humphreys, C. E. K. *Marshfield Almshouses*. R. Youdan, 1999.

Imray, Jean. *The Charity of Richard Whittington*. The University of London, 1968.

Latta, Caroline, and Molyneux, Nicholas. *The Commandery or The Hospital of St Wulstan, Worcester*. Worcester City Museum Service, 1981.

MacFarquhar, G. I. *Leamington Hastings Almshouses and Poor's Plots*. 1982.

Manco, Jean. *The Spirit of Care*. St John's Hospital, Bath, 1998.

McIlwain, John. *The Hospital of St Cross and St Cross Church*. Pitkin, 1999.

Miles, Ellis. *Browne's Hospital, Stamford, Lincolnshire.* No date given.

Munby, Julian. *St Mary's Hospital, Chichester.* 1987.

Page, Patrick. *The Fishermen's Hospital.* The Great Yarmouth Municipal Charities, 2002.

Parkin, David. *The History of Gilson's Hospital, Morcott.* Rutland Local History and Record Society Occasional Publication No. 4, 1995.

Parkin, David. *The History of the Hospital of Saint John the Evangelist and of Saint Anne in Okeham.* Rutland Local History and Record Society Occasional Publication No. 6, 2000.

Phillips, Elaine. *A Short History of the Great Hospital, Norwich.* The Great Hospital, Norwich, 1999.

Philo, Phil. *Kirkleatham.* Langbaurgh on Tees Museum Service, no date given.

Porter, Stephen, and Richardson, Harriet. *The Charterhouse.* English Heritage, 2000.

The Quest Community at Glastonbury. *Ancient Hospitality at Glastonbury.* No date given.

Sackville-West, V. *Sackville College.* 1962 (1990 reissue).

Salisbury Local History Group. *Caring.* Salisbury City Almshouses and Welfare Charities, 2000.

Sanders, B. G. *St Katherine's Hospital* (Ledbury, Herefordshire). No date given.

Scott, Allan. *The Royal Naval College, Greenwich.* Woodmansterne, 1987.

Smith, Martin. *Stamford Almshouses.* Stamford and District Tourist Association, 1990.

Sotheran, Peter (editor). *Sir William Turner and His Hospital in Kirkleatham.* Board of Trustees, 2001.

Woodfield, Charmian and Paul. *Lyddington Bede House.* English Heritage, 1999.

Guide to St Mary's Church, Ewelme, and to the Almshouse and the School. No date given.

Lord Leycester Hospital, Warwick. S. P. Graphic Design, no date given.

The Royal Hospital, Chelsea. Jarrold Publishing, 1993.

Waddington Hospital. The Trustees, 1979.

Wyatt's Almshouses, Godalming. The Carpenters' Company, no date given.

In many places the local tourist office may have a leaflet, town trail or guide showing the whereabouts of almshouses. The Internet can also be helpful.

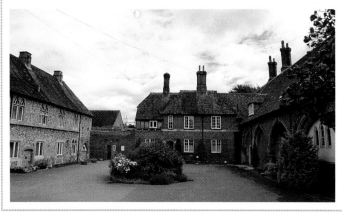

St Nicholas Hospital, Salisbury. Note the two arches on the right, representing the entrances to the former twin infirmary halls and chapels. Both chapels and the south hall can still be traced but the north hall has disappeared. Most of the other buildings are Victorian.

Places to visit

The exterior of most almshouses can be enjoyed by anyone passing by. Sometimes it is possible to view a courtyard or visit a chapel, always remembering to respect the privacy of those who live in the communities. In a number of cases the tomb of a benefactor can be found in the local church.

Some foundations open their doors to the public at certain times of the year on specific days of the week. On Heritage Open Days in September each year a few almshouses open up parts of their buildings, some of them organising guided tours. In all cases it is advisable to contact the local tourist information centre for details.

The following list is by no means comprehensive and the author would welcome information on institutions not included.

ENGLAND

Abingdon (Oxfordshire). Here five sets of almshouses can be found. Three of these – *Long Alley Almshouses* (or *Christ's Hospital*), *Brick Alley Almshouses* and *Twitty's Almshouses* – are grouped behind St Helen's Church (inside which is an inscription 'To the Happy Memory of Charles Twitty, Esqr'). The oldest of these, *Long Alley Almshouses*, are sometimes open to the public. The founder of *Tomkins Almshouses* in Ock Street has a tomb outside the Baptist chapel in the same road. *St John's Almshouses* can be found in Vineyard. For further details please contact the tourist information centre. Telephone: 01235 522711.

Beamsley (near Skipton, North Yorkshire). *Beamsley Hospital* is a holiday cottage belonging to the Landmark Trust, Shottesbrooke, Maidenhead, Berkshire SL6 3SW. Telephone: 01628 825925. Website: www.landmarktrust.co.uk The chapel can be visited by appointment, by telephoning the number given.

Bedworth (Warwickshire). The grade two listed *Nicholas Chamberlaine Almshouses* in All Saints Square, complete with imposing governors' hall, minstrels' gallery, chapel, cloisters and pump house, have open days twice yearly, with tours of the complex. For further details please contact the Bedworth Society. Telephone: 024 7661 9126.

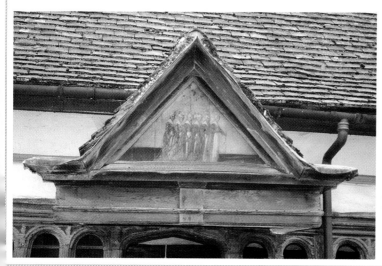

One of the gables of the Long Alley Almshouses in Abingdon, with a picture by the Oxford artist Sampson Strong.

53

The Nicholas Chamberlaine Almshouses in Bedworth (Warwickshire), an eighteenth-century foundation rebuilt in 1840.

Bristol. Among the many foundations in this city, *Foster's Almshouses* has opened the doors of its chapel, dedicated to 'The Three Kings of Cologne', on Heritage Open Days. For further details please contact the tourist information centre. Telephone: 0117 926 0767.

Bruton (Somerset). The courtyard with chapel and bust of the founder of *Hugh Sexey's Hospital* can be glimpsed from the street entrance.

Castle Rising (Norfolk). The hall and chapel of the *Hospital of the Holy and Undivided Trinity* are open at regular times. For further information please contact King's Lynn tourist information centre. Telephone: 01553 763044.

Chelsea (London). The grounds and some of the buildings of the *Royal Hospital*, including a museum and shop, are open to the public. The famous Wren chapel has services on Sundays. Royal Hospital Road, Chelsea, London SW3 4SR. Telephone: 020 7881 5203.

Chichester (Sussex). *St Mary's Hospital* is open to visitors at regular times. For opening hours please contact the tourist information centre. Telephone: 01243 775888.

Clerkenwell (London). The *Charterhouse* is open on certain days during the summer. For further details please contact the British Tourist Authority. Telephone: 020 8846 9000.

Clun (Shropshire). The courtyard (with a statue of two pensioners) and chapel of the *Hospital of the Holy and Undivided Trinity* are open to view.

Cobham (Kent). The *New College,* originally a chantry college for priests, is now a foundation for retired people. For opening times please contact Gravesend tourist information centre. Telephone: 01474 337600.

Cossall (Nottinghamshire). The *Willoughby Almshouses* have two walls in front of them, one higher than the other, forming an early traffic barrier. One nineteenth-century pensioner was a survivor of the battle of Waterloo. The village provided D. H. Lawrence with a background for some of his novels.

Coventry (Warwickshire). Both *Ford's Hospital* and *Bond's Hospital* are timber-framed. The tiny picturesque courtyard of the former is visible from the street. Writing along its walls tells the visitor that at one time a couple received $7^1/2$d per week. If the man's wife were to die he could keep that amount, but if it were the husband that

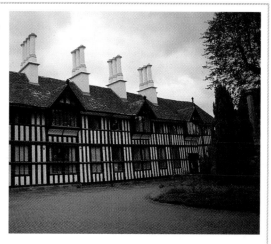

Bond's Hospital in Coventry was founded in 1506 by Thomas Bond, a draper and the city's mayor in 1497–8.

died his widow's income would be reduced to half the amount. The interior of Bond's Hospital can sometimes be viewed on Heritage Open Days. For more information please contact the tourist information centre. Telephone: 024 7622 7264.

Croydon (Surrey). The courtyard of Bishop Whitgift's *Hospital of the Holy Trinity* in North End can be glimpsed through the entrance gate. The founder has a splendid tomb in the parish church, opposite which are the former Elis David Almshouses.

Dorchester (Dorset). *Napper's Mite*, the almshouse founded by Sir Robert Napier in 1615, with its bell turret and large external clock, has been converted to a miniature shopping centre with café. It is located in South Street.

Dulwich (London). Sir John Soane's Art Gallery contained almshouses for six 'Poor Sisters' until alterations made by Charles Barry Junior in the 1860s turned the space into display rooms six and nine. The elderly women were moved to the adjoining *Old College of God's Gift* (founded by Edward Alleyn in the seventeenth century), where they occupied the vacated college building, joining the retired men who were already on the site. For gallery opening hours please telephone 020 7405 2107.

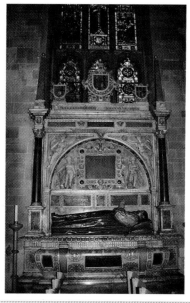

East Grinstead (Sussex). *Sackville College*, founded by Robert Sackville, second Earl of Dorset, opens its doors to visitors during the summer, with tours including the common room, the great hall, the chapel and the warden's study. For opening times please telephone 01342 326561.

Etwall (Derbyshire). *Etwall Hospital*, established in 1550 by Sir John Port (who also founded Repton School), can be viewed through fine wrought-iron gates. The founder's tomb is in the nearby St Helen's Church.

Bishop John Whitgift's tomb in the parish church of Croydon, Surrey.

The central frontispiece of the almshouses in Etwall (Derbyshire), rebuilt in 1681.

Ewelme (Oxfordshire). The almshouses, founded by the Duke and Duchess of Suffolk, are next to the church, which can be reached from the cloistered courtyard via a covered staircase. Inside the church is the splendid tomb of Alice de la Pole, Duchess of Suffolk, Geoffrey Chaucer's granddaughter and one of the few women admitted to the Order of the Garter. The tomb shows Alice wearing the Garter on her left arm, providing inspiration for Queen Victoria, who followed her example. In the centre of the village a set of modern almshouses was built by the same charity in 1977.

Frolesworth (Leicestershire). The chapel in the courtyard of the *Baron Smith Almshouses* is usually open.

Glastonbury (Somerset). The *St Mary Magdalene Almshouses* off Magdalene Street illustrate the transition from hall hospital to rows (of which only one is left) of almshouses. Modern almshouses can be seen behind. The chapel of St Margaret, which despite having a different name was part of the hospital, is usually open. The site is run by the Christian Quest Community. Telephone: 01458 835235. Also in Glastonbury are the chapel of the former *St Patrick's Almshouses* (within the grounds of the abbey ruins) and the *Austin Almshouses* of 1887.

Godstone (Surrey). The chapel of *St Mary's Homes*, with its portrait of Mabel Fanny Hunt, in whose memory the almshouses were built by her mother, Augusta Nona Hunt, is usually open to visitors.

Greenwich (London). Some areas of the former *Royal Naval College*, including the Painted Hall and Chapel, are open to the public. The Queen's House, now a museum containing paintings relating to the hospital, at one time served as the governor's private residence. The hospital burial ground, to the right of the National Maritime Museum, contains a mausoleum with the tomb of Captain Hardy, commander of Nelson's ship *Victory* at the Battle of Trafalgar, later governor of the hospital. There is also a tombstone to Nelson's faithful servant Tom Allen, who was a pensioner at the hospital, though not a retired seaman. For opening hours

A portrait of Mabel Fanny Hunt, the only child of the widowed Mrs Augusta Nona Hunt. The St Mary's Homes in Godstone (Surrey) were built in Mabel's memory by her mother.

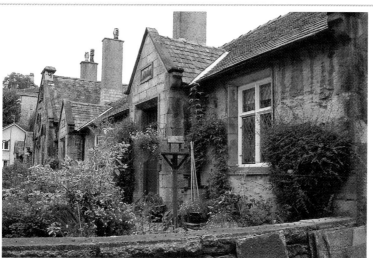

please contact the tourist information centre. Telephone: 0870 608 2000. Those interested may wish to take the foot tunnel to the other side of the river Thames for the best view of the whole complex of buildings. Also in Greenwich are *Queen Elizabeth's College* in Greenwich High Road, the *John Penn Almshouses* in Greenwich South Street and the Earl of Northampton's *Trinity Hospital* alongside the river Thames (next to the power station).

Guildford (Surrey). The *Hospital of the Blessed Trinity* in the High Street has an impressive entrance, from where the courtyard can be viewed. Inside can be found an alms box. The founder, George Abbot, has an elaborate tomb in the parish church opposite and a statue close by.

Hereford. *Coningsby Hospital* in Widemarsh Street incorporates the remains of a house built by the Order of St John of Jerusalem. The courtyard contains a chapel and a pump. Behind the building are the remains of a monastery. The chapel and museum are open in the summer months. For further information please contact the tourist information office. Telephone: 01432 268430.

Kendal (Cumbria). The courtyard and former chapel of *Sandes Hospital* can be viewed from the gatehouse in Highgate. The datestone has a representation of shearmen's tools, the coat of arms of the founder, Thomas Sandes, a cloth merchant. Inside the entrance is an alms box in the wall. Also in Kendal are the *Sleddall Victoria Jubilee Almshouses* of 1887, with their former chapel, in Aynam Road and the *Mrs John Aston Watkins Almshouses* of c.1928 in Romney Road.

King's Cliffe (Northamptonshire). *Law's Almshouses* can be found on either side of Bridge Street. Between 1727 and 1754 William Law, theologian, writer and benefactor, founded two charity schools and a library, as well as the almshouses. His tomb in the churchyard is in the shape of a writing desk. Also in King's Cliffe are the *Thorpe Almshouses* and the *Cornforth Homes*.

The poor-box inside the entrance to Sandes Hospital, Kendal (Cumbria).

Kirkleatham (Yorkshire). The *Sir William Turner Hospital* can be viewed through its splendid gates. During the summer the chapel is open on certain Sundays. Nearby, in the Old Hall, is the *Kirkleatham Pavilion Museum*, with some displays dedicated to the almshouses. The parish church has a magnificent mausoleum attached, containing the founder's tomb. For further information please contact the museum. Telephone: 01642 479500.

Lambourn (Berkshire). The pretty cloistered courtyard of the *Estbury Almshouses* can be seen from the impressive entrance. The founder's tomb, with brass, is in the church opposite. *Place's Almshouses* and *Hardrett's Almshouses* are round the corner from the Estbury Almshouses.

Ledbury (Herefordshire). Whereas the restored chapel of the former *St Katherine's Hospital* is still attended by the pensioners living in the nineteenth-century row of almshouses next to it, the rest of the building is used as a community centre, regularly opening its doors to the public, allowing the fourteenth-century roof to be admired. Inside the parish church is the wall monument of Thomas Thornton, master of the hospital from 1612 to 1629, in a preaching attitude. The former master's house lies behind the almshouses and is now used as offices.

Lichfield (Staffordshire). The courtyard and chapel of *St John's Hospital* are open to the public. The chapel has a stunning east window by John Piper. Note also the imposing master's house. Also of interest are *Dr Milley's Hospital* in Beacon Street and the former *Newton's College* and modern addition to St John's in the Cathedral Close.

Lyddington (Rutland). The *Bede House* is an English Heritage property. It is open during the summer. Telephone: 01572 822438.

Newland (Worcestershire). The *Beauchamp Almshouses* and church can be viewed from the entrance arch.

Ospringe (Kent). The *Maison Dieu*, relatively unchanged in four hundred years, is at times open to the public. For further details please contact the Faversham Society. Telephone: 01795 534542.

Paul (Cornwall). *Hutchens House*, founded in 1729 by Captain Stephen Hutchens, is one of the oldest buildings in the village. The founder's tomb, with a Cornish inscription,

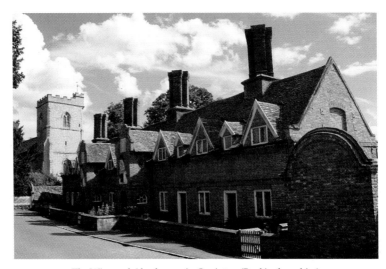

The Winwood Almshouses in Quainton (Buckinghamshire).

can be found in the church.

Penge (London). The former *King William IV Naval Asylum* in St John's Road is round the corner from the former almshouses built by the Company of Watermen and Lightermen of the River Thames, off the High Street. Both are worth making a detour for.

Preston upon the Weald Moors (Shropshire). The *Herbert Almshouses* are reached via two lodges and magnificent wrought-iron gates.

Quainton (Buckinghamshire). The picturesque row of almshouses is next to the church where the founder, Richard Winwood, has a splendid tomb.

Rothwell (Northamptonshire). The courtyard of *Jesus Hospital* can be seen from the entrance in the town centre.

Salisbury (Wiltshire). The city has a large number of almshouses, most of which are described in the book *Caring* (available from the Salisbury City Almshouse and Welfare Charities at Trinity Hospital, Trinity Street, Salisbury SP1 2BD). *Trinity Hospital's* chapel, at the far end of its pretty courtyard, is usually open during the day. For further details please contact the tourist information centre. Telephone: 01722 334956.

Sherborne (Dorset). The *Almshouse of SS John* is at times open to the public. For further details please contact the tourist information office. Telephone: 01935 815341.

Shoreditch (London). The former *Geffrye Almshouses* are now a museum dedicated to English domestic interiors from 1600 to the present. Two of the former almshouses are furnished to represent the lifestyle of an almswoman in the eighteenth and nineteenth centuries. During the summer the award-winning garden can be visited. The small graveyard contains the tomb of the founder, Sir Robert Geffrye, whose monument can be seen in the chapel. A modern extension contains space for changing exhibitions, a café and a shop. For opening hours please telephone 020 7739 9893.

Stamford (Lincolnshire). This town has many almshouses, amongst them *Browne's Hospital* in Broad Street, which has an interesting museum. For opening times please contact the tourist information centre in St Mary Street. Telephone: 01780 755611. A town trail, listing the various charitable institutions, may be available in the museum in Broad Street.

Sutton Cheney (Leicestershire). The former almshouses are now a guesthouse with restaurant attached. Telephone: 01455 291050. The nearby church (in which King Richard III took his last communion on the eve of the Battle of Bosworth in 1485) contains the tomb of the founder, Sir William Roberts.

Tamworth (Staffordshire). The almshouses founded by Thomas Guy (also founder of Guy's Hospital, London) can be seen from the courtyard entrance in Gungate.

Temple Balsall (Warwickshire). The *Hospital of Lady Katherine Leveson* (granddaughter of Robert Dudley, Earl of Leicester), the nearby St Mary's Church and the Old Hall (formerly the bailiff's house) were built on land that once belonged to the Templars and Hospitallers. The site, including the old graveyard with the small round headstones of former dames, has been declared a special conservation area and has ancient monument status. The hospital is usually open on Heritage Open Days. For dates of these, please telephone the Warwick tourist information centre on 01926 492212 or visit the hospital website at www.templebalsall.org.uk

Waddington (Lancashire). The chapel of the *Hospital* is open to visitors, who should note the ceramic bust of the founder, Robert Parker. The courtyard contains an interesting pump, the only part of this charming complex that is listed, and a sundial.

Wantage (Oxfordshire). The town has three sets of almshouses, *Town Lands Almshouses*, *Eagle Homes Almshouses* and *Stile's Almshouses* (the gift of a merchant from Amsterdam). The entrance to Stile's Almshouses leads to a passage that is partly paved with sheep's knuckle-bones.

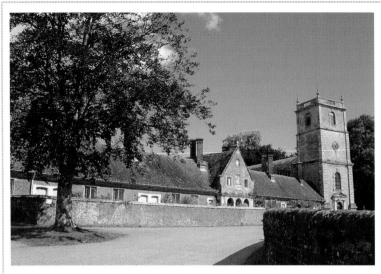

The almshouses built by Sir Anthony Ashley in Wimborne St Giles (Dorset).

Warwick. The *Lord Leycester Hospital* dominates the West Gate of the town, above which its chapel is built. Occupied by the master and brethren, this former guildhall contains a small museum. The former kitchen and dining room, just off the picturesque courtyard, have been turned into a café. Also open to the public is the master's garden, partly enclosed by the town wall, containing a Norman arch, an urn-shaped Roman nilometer (used for measuring the height of the Nile for taxation purposes) and a thatched summer-house. For further information please contact the hospital. Telephone: 01926 491422. At the other end of the town is the row of *Oken's and Iffeler's Almshouses*, opposite the castle wall.

Wells (Somerset). Overlooking St Cuthbert's churchyard is a cluster of four sets of almshouses: *Bubwith's Almshouses*, *Still's Almshouses*, *Willes' Almshouses* and *Bricke's Almshouses*, the last with four canopied seats outside. Close by are *Llewellyn's Almshouses* and *Harper's Almshouses*. The tombs of Bishop Still and Bishop Bubwith can be found in the cathedral.

West Stockwith (Nottinghamshire). Though William Huntington's almshouses in this riverside village have disappeared, a large monument to the founder is situated in the little church 'round a bout' which they were built.

Wimborne St Giles (Dorset). The almshouses, built by Sir Anthony Ashley, are next to the church, in which his tomb can be found.

The Commandery in Worcester incorporates the Hospital of St Wulstan.

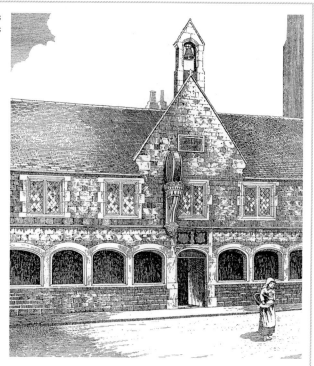

The large clock outside Napper's Mite in Dorchester (Dorset) is quite an eye-catcher.

Winchester (Hampshire). The *Hospital of St Cross* is at times open to the public. Here, uniquely, the Wayfarer's Dole of 'a morsel of bread and a horn of beer' is offered to visitors. For opening times please contact Winchester tourist information centre. Telephone: 01962 840500.

Wirksworth (Derbyshire). Anthony Gell, the founder of the modest bede houses overlooking St Mary's churchyard, has an interesting tomb and plaque describing his achievements in the church (which also contains some splendid Saxon carvings).

Worcester. This city has a number of almshouses. The *Berkeley Hospital* in Foregate, *Laslett's Almshouses* in Union Street, and *St Oswald's Hospital* and the *Queen Elizabeth Almshouses* in Upper Tything can be viewed from the road. The *Hospital of St Wulstan* in Sidbury has mostly been absorbed by the building known as The Commandery, a museum with Tudor and Stuart interiors, dedicated to the English Civil War. For opening hours please contact Worcester tourist information centre. Telephone: 01905 726311.

Wotton-under-Edge (Gloucestershire). The entrance of *Perry's Almshouses* on Ludgate Hill leads to a courtyard surrounded by *Dawes Almshouses* and the *General Hospital*. The detached chapel is usually open. Note the inscription above the doorway on the courtyard side, detailing the almshouse rules. Also can be found the *Ann Bearpacker Almshouses* (built with black-pointed stone) and the *Rowland Hill Almshouses*.

York. This city has a large number of almshouses. Among these the former *Lady Ann Middleton Hospital* in Skeldergate is now a hotel. Telephone: 01904 611570. The former *Terry Memorial Homes*, situated in the front garden of the hotel, is now a brass-rubbing centre. Telephone: 01904 611570.

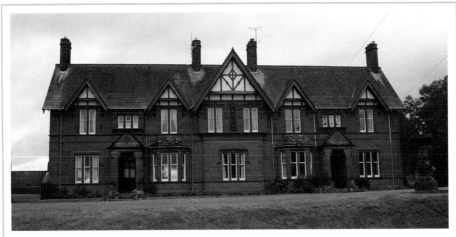

Johnstone Cottages, Dumfries.

SCOTLAND

Dumfries. The *Carruthers Cottages* and *Johnstone Cottages* can both be found in Johnstone Park. *Moorheads Hospital* is situated on the corner of Bridge Street and St Michael Street.

Edinburgh. The *Aged Christian Friend Society of Scotland Cottage Homes* are in Redford Road, Colinton; the *Sir William Fraser Homes* in Spylawbank Road, Colinton; and the *Lockerby Trust Almshouses* (or *Cottages*) in Lasswade Road. The Scottish Veterans' Residences in *Whitefoord House* are situated in Canongate and those in the *Murray Home* in Gilmerton Road.

Glasgow. *Provand's Lordship* in Castle Street is the oldest house in the city. It was built in 1471 for the chaplain to St Nicholas' Hospital (which no longer exists). It is now a museum with displays of period furniture. Telephone: 0141 552 8819. *Hutcheson's Hall* (formerly Hutcheson's Hospital) in Ingram Street is a listed building owned by the National Trust for Scotland. For further details please telephone 0141 552 8391.

Inverness. *Dunbar's Hospital* in Church Street has a 'pop-in' centre for senior citizens to which all pensioners are welcome.

Stirling. The former *Cowane's Hospital* in St John Street, Stirling Old Town, is used as a venue for traditional entertainment, medieval banquets and concerts. It usually opens its doors on Heritage Open Days. In the Church of the Holy Rude (opposite) can be found stained-glass windows and commemorative plaques to John Cowane, whose private house is situated in Mary's Wynd. For further information please contact the tourist information centre. Telephone: 01786 475019. The former *Spittal's Hospital*, founded by King James IV's tailor, Robert Spittal, is situated in Spittal Street and can be recognised by the plaque displaying a large pair of shears.

WALES

Caerwent (Monmouthshire). The *Burton Homes*, possibly built on the site of a Roman temple, can be found near the East Gate in the Roman wall, on which it looks out.

Chepstow (Monmouthshire). The *Powis Almshouses*, with their sundial and plaque, are located at the top of Bridge Street and the *Montague Almshouses* in nearby Upper Church Street.

The almshouses in Llanrhaeadr (Denbighshire).

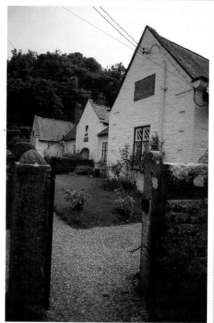

Corwen (Denbighshire). *The College*, formerly almshouses for the widows of clergymen of the Church of England, is now a retreat centre known as *Coleg y Groes*, run by a Christian community. Telephone: 01490 412169. Email: colegygroes@talk21.com Website: www.colegygroes.co.uk Just outside the town, along Bala Road, are the former almshouses, now privately owned, which were built by the Vaughan family of Rhug for retired servants.

Hay-on-Wye (Powys) has two sets of almshouses built by Frances Harley, one in memory of her mother, the other of her sister, as well as the *Gwynn's Almshouses*.

Knighton (Powys). The very charming *Green Price Almshouses*, with their half-timbered gables, are situated near the church.

Llanrhaeadr (Denbighshire). Behind the church of St Dyfnog, and not far from the holy well associated with that saint, lie the Georgian almshouses built and maintained by members of the Bagot family of Blithfield in Staffordshire.

Llanrwst (Conwy). The seventeenth-century *Jesus Hospital* can be found in Church Street.

Llanwrda (Carmarthenshire). The *Lady Laetitia Cornwallis Almshouses* can be seen from the main road.

Machynlleth (Powys). The almshouses built by Mary Cornelia, Viscountess Vane (later the Marchioness of Londonderry), are opposite the churchyard belonging to the parish church of St Peter. They are now a private house. A bust of the founder is situated in the gardens surrounding her former home, now a visitors' centre known as Celtica.

Monmouth. William Jones's original seventeenth-century almshouses were rebuilt in 1842 and now form part of the Haberdashers' School, founded by the same benefactor. To replace their loss, a new group of almshouses was built in 1961. One of the buildings on this site was provided mainly as a result of money left by Mrs Kate Lillian Midwinter, who nursed the alms people for twenty-two years. The *Burton Homes* have a splendid turreted gateway.

Ruthin (Denbighshire). *Christ's Hospital* (*Ysbyty Crist*) lies to the east of St Peter's Church and is situated behind a pleasant green.

St Asaph (Denbighshire). The former Barrow Almshouses in the High Street have been turned into a restaurant called the *Barrow Arms*. Telephone: 01745 582260. Bishop Barrow's tomb can be found outside the west end of the cathedral.

Welshpool (Powys). The almshouses, built with the bequest of T. J. Evans, former mayor of the town, in 1940, can be found opposite the old railway station, now a retail outlet.

Index